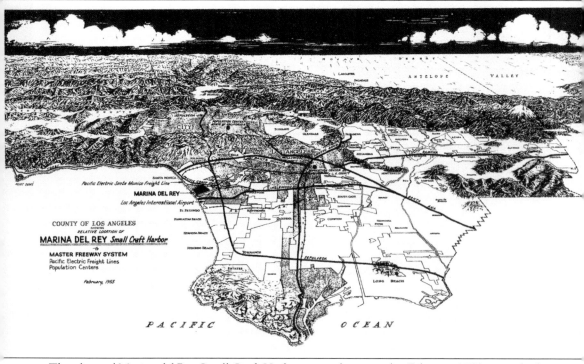

The planned Marina del Rey Small Craft Harbor site is shown in this February 1955 map, which was included in the county's bidder's packet for prospective leasehold developers. The railway tracks no longer exist. The dark, small rectangle representing Marina del Rey (center left) is six miles north of Los Angeles International Airport and sits below the Playa del Rey bluffs. (Courtesy of County of Los Angeles.)

ON THE COVER: Marina del Rey's main channel is 1,000 feet wide, 20 feet deep, and 1 mile long, and it was engineered to true north-south headings. The six-sided clubhouse of California Yacht Club and anchorage are visible alongside Basin F in the left foreground of this 1969 photograph. Marina del Rey Hotel, formerly the Sheraton hotel, is the building with boat slips at center left. The vacant dirt lot (mole) in the upper left became Burton Chace Park next to Basin H, the commercial water section for boat repair and the small-boat launch ramp. (Courtesy of County of Los Angeles.)

Marina del Rey Historical Society

Copyright © 2014 by Marina del Rey Historical Society
ISBN 978-1-4671-3180-3

Published by Arcadia Publishing
Charleston, South Carolina

Printed in the United States of America

Library of Congress Control Number: 2013954910

For all general information, please contact Arcadia Publishing:
Telephone 843-853-2070
Fax 843-853-0044
E-mail sales@arcadiapublishing.com
For customer service and orders:
Toll-Free 1-888-313-2665

Visit us on the Internet at www.arcadiapublishing.com

To Mimi and Greg Wenger of Marina del Rey, whose farsighted efforts to preserve historic photographs and documents make this book possible.

Contents

Acknowledgments 6

Introduction 7

1. Marshland, Port Ballona, Oil, Mud Lake, Hoppyland 11
2. Vision, Ground Breaking, Water Infrastructure 23
3. Storm Surge Destruction, Solution, Success 41
4. Land Development, Fisherman's Village, Public Services 61
5. Boating, Recreation, Yacht Clubs 93
6. Visionaries, Celebrities, Community 111

About the Organization 127

Acknowledgments

The opportunity to showcase the origins and development of the magnificent engineering accomplishment called Marina del Rey was too enticing to pass up for the recently established Marina del Rey Historical Society (MDRHS). In addition to Mimi and Greg Wenger, volunteer editors, writers, and researchers are Rikki Barker, Janet Bubar Rich, David Maury, Patrick Reynolds, Liz Hjorth, Tim Tunks, Judith Endler, Christopher Gillum, Tom McMahon, and Willie Hjorth. They generously donated time and expertise to compile information and images for this work.

Thanks go to Laura Willette Miller and Donna Willette Wooley, and to Mike Priest, for sharing their personal stories and photographs of Lake Los Angeles, also known as "Mud Lake," and of Hoppyland.

We are most grateful to Alan H. Jutzi, Avery Chief Curator, Rare Books, of the Huntington Library, for making available Los Angeles County Regional Planning (LACRP) documents from 1938 to 1965.

Very special thanks go to Los Angeles County Department of Beaches and Harbors (LACDBH), Los Angeles County Fire Department (LACFD), and LACRP for the use of photographs and documents.

We extend gratitude to the donors of Summa Corporation, Security Pacific National Bank Historical Collection (SPNBHC), and the named individuals and organizations who have shared their archives in this work.

A huge debt of gratitude goes to Dan Khoury and Christina Maury for their invaluable technical support. We thank Gary Thornton, retired Marina del Rey harbormaster, and former Fisherman's Village general manager Stan Berman for making available their documents. Special appreciation for their encouraging support is extended to MDRHS board members Howard Wenger, Barbara Slavin, Debbie Talbot, and Ken Englert.

Courtesy for images used are named throughout, including the following: Los Angeles County Board of Supervisors (LACBS); Los Angeles County Regional Planning (LACRP); Los Angeles County Department of Beaches and Harbors (LACDBH); Los Angeles County Fire Department (LACFD); and Security Pacific National Bank Historical Collection (SPNB Collection).

INTRODUCTION

What started as one man's vision in 1887 has become a booming recreational boating utopia. The man was Moye L. Wicks, a real estate speculator. His vision was to transform Playa del Rey's estuary into a major commercial harbor for the Atchison, Topeka & Santa Fe Railway to support shipping demands for the increased import and export of goods.

With the idea of establishing this area as a commercial harbor for Los Angeles, Wicks organized the Port Ballona Development Company to raise money for developing the area. Within three years, however, the company went bankrupt. The wharf that Wicks's Port Ballona Development Company built in the early 1900s was destroyed by seasonal heavy rains and flooding. The site, formerly part of the Machado Mexican-Spanish land grant, reverted back to a marshland, rich with ducks, fish, and birds.

The wildlife haven became a recreational playground for duck hunters and fishermen, as well as a destination for location shoots in the burgeoning motion picture industry. Culver City, home since 1918 to movie studios, including Metro-Goldwyn-Mayer, was within three miles of the wetlands. Culver City residents picnicked on the estuary banks of the meandering Ballona Creek, whose flooding propensity was finally tamed by concrete revetments built by the US Army Corps of Engineers in 1938.

Small commercial stores lined the Culver City roads through the farmland to the popular city of Venice, known for its laid-back beaches, vacation cottages, and elaborate canal system once provisioned with gondolas and gondoliers. Wide-ranging entertainment venues, from bathhouses and theaters to coffeehouses and cafés, served alcoholic beverages in the early 1900s when other communities would not. With the discovery of oil in Venice in 1929, the boom was on. Oil wells were limited to two per city block. By 1932, the oil, once offering hope to so many, left the marshland riddled with oily residue attracting mosquitoes, crime, and the need for expensive mosquito-abatement maintenance.

A 1916 study by the Corps of Engineers deemed the Ballona area impractical for a harbor. Following the Great Depression, the harbor idea was reopened for review in 1936 by Congress and the Los Angeles County Board of Supervisors. Intensive economic feasibility studies were prepared in 1938 by the Los Angeles County Regional Planning Commission to develop the area into a recreational harbor, after San Pedro was chosen as the preferred site for the international commercial Port of Los Angeles.

Thus, the vision of Marina del Rey ("Harbor of the King") for pleasure-boating was born. Plans were set aside due to World War II. In 1949, the Corps of Engineers submitted a plan to Congress outlining the feasibility of constructing a harbor in the Playa del Rey inlet area for up to 8,000 boats, at an estimated cost of $24 million. A revised master plan was given first priority. Prominent county advocates Rex Thomson and Arthur Will pushed for the transformation of the former tidal marsh and oil field into a modern harbor and community.

Financing was obtained in 1953 from the California State tidelands' oil revenues to purchase much of the harbor site. In 1954, civic leaders and politicians, led by newly elected supervisor

Burton W. Chace of the Fourth District, County of Los Angeles, lobbied for funding legislation from the State of California, the City and County of Los Angeles, and the federal government. Later in 1954, Pres. Dwight Eisenhower signed Public Law 780, making the harbor an authorized federal project. Federal, state, city, and county funds were committed, with voters approving a $13 million municipal revenue bond issue in 1956 to raise funds to build the water infrastructure.

In the process of designing and building more effective drainage for the flood control system in 1938, the Corps of Engineers built a concrete channel to contain Ballona Creek, creating a deeper body of water where the present Playa del Rey (Ballona) Lagoon is located. A second body of water, adjacent to what is now Marina del Rey, evolved as a flood-control basin. Known as Lake Los Angeles, Mud Lake, or Lake Venice, it became a recreational hot spot for small sailboats and ski boats in the 1950s, and it offered a glimpse of the future. These boating enthusiasts would later bring their sailing expertise to the new Marina del Rey and organized boating events and yacht clubs.

The marina's current Marina Beach, known as "Mother's Beach," sits on the site of the former Mud Lake in Basin D. Part of the Mud Lake sand area was known as Hoppyland, a carnival site of rides and merry-go-rounds operated by William Boyd, a film star who portrayed the television cowboy Hopalong Cassidy. Adjacent to his amusement park was the Lake Los Angeles Riding Club and Stables, owned and operated by Walter Leroy "Roy" Willette. Hoppyland closed in 1954, and the riding club moved on October 31, 1959.

Ground-breaking ceremonies to begin Marina del Rey's construction took place on December 11, 1957, at the site of the future opening of the entrance channel, adjacent to the jetties of Ballona Creek. The three remaining oil wells were capped, and the dredging of the modern footprint for the channels began. Soil was moved to mounds, which would ultimately become the land sites (moles) enclosed in concrete walls, with underground utilities readied for future development. Los Angeles citizens watched in awe as the 804-acre harbor took shape.

By November 1958, the jetties for today's harbor entrance were completed. Each of the eight water basins, A through H, was sequentially dredged. Reinforced concrete bulkhead/headwalls were poured. Pilings were driven to hold docks for boat slips. With the arrival of the first boats in 1962, Marina del Rey was a reality.

In the winter of 1962–1963, severe winter storms brought storm surge directly into the harbor, destroying docks and pilings. News reports repeated the claim that the fury of the Pacific Ocean would defeat the man-made engineering marvel. Land developers were suddenly without financing to build out the dirt moles. Dire forecasts of "Chace's Folly" or "Chace's White Elephant" beset the county board of supervisors.

Enter a coterie of businessmen, developers, and elected representatives from county, state, and congressional levels tasked to speed up the research of the Corps of Engineers' Waterway Experiment Station at Vicksburg, Mississippi, to solve the excessive vulnerability of the harbor to wave action. A permanent detached breakwater was recommended. Civic leaders, government officials, and land developers who firmly believed in the successful economic vision of Marina del Rey sought to raise the additional monies required to build the breakwater.

When interviewed in 2011, Jerry Epstein, the last living original major Marina del Rey land developer (Del Rey Shores), told the Marina del Rey Historical Society that he and Aubrey Austin Jr., president of Santa Monica Bank and chairman of the county's new Small Craft Harbor Advisory Committee, "hitched an airplane ride from March Air Force Base to Washington, DC. We walked the halls of Congress lobbying for funds to build the breakwater. The county had little lobbying presence in those days." But with the help of Sen. Clair Engle, Congressman James Roosevelt, and Sen. Thomas H. Kuchel, funding was obtained to ferry rocks and boulders from the quarry on Catalina Island to build the breakwater, beginning on October 15, 1963.

Temporary sheet-pile baffles were placed strategically across the entrance channel to give vital protection to the harbor while the detached breakwater was built. In 1965, the breakwater was completed, the baffles were removed, and the permanent existence of Marina del Rey was ensured.

Private developers financed and built everything from multi-residential complexes, hotels, popular restaurants, and nightspots to marine stores and retail businesses, yacht brokerage offices, yacht clubs, banks, medical buildings, and grocery stores. Among the 1962 developments were the Pieces of Eight restaurant and the Sheraton hotel (with its Golden Galleon lounge), later renamed the Marina del Rey Hotel. Joining these would be the Warehouse, Cyrano's, Fiasco, Donkins Inn, the Randy Tar, Lobster House, Captain's Wharf, and Don the Beachcomber.

Fisherman's Village, consisting of Cape Cod–style shops, opened in 1969, featuring traditional tall ship tours, harbor cruises, and an aquarium. Public services were provided to Marina del Rey by the Los Angeles County Fire Department and by the Harbor Patrol, which was later merged into the Los Angeles County Sheriff's Department. The nonprofit Marina Foundation, established in 1980, funded the addition of a nautical section to the Marina del Rey County Library to further enhance public access to marine-related resources.

In March 1963, the Pioneer Skippers Boat Owners Association was formed by experienced boat owners who brought their craft from other harbors to be closer to their Los Angeles residences. They organized social activities in the new marina and advised the harbor department on necessary navigational aids, channel markers, dock facility maintenance, as well as other boating issues. The organization founded the renowned Christmas Boat Parade, now Holiday Boat Parade, a continuing winter attraction for hundreds of spectators and participants.

Currently, Marina del Rey has 4,100 boat slips in 21 anchorages. Launch ramp facilities provide marina access for over 100,000 trailer-class boats. Yacht clubs and other social groups continue to promote year-round events and cruises. World-class yacht races, fishing derbies, and boat parades fill much of the boating calendar.

Among the public parks in Marina del Rey are the following: Yvonne Braithwaite Burke Admiralty Park, with its self-guided exercise path for fitness enthusiasts; Aubrey E. Austin Jr. Park, with its benches and spectacular views of the entrance channel; and Harold Edgington Park, honoring an early harbor patrolman.

The 10-acre park and centerpiece of community interaction in Marina del Rey is Burton W. Chace Park at 13650 Mindanao Way, named after the 1954 Los Angeles County supervisor who led the development of Marina del Rey. Notably, the park has a statue called *The Helmsman*. This statue stood in front of, and was a trademark for, the well-known Helms Bakery on Venice Boulevard in Los Angeles for many years. On October 6, 1971, the Helms family generously donated it to the marina, where it has become a Marina del Rey landmark.

Bordered by Playa del Rey to the south and Venice to the north, and located about six miles north of Los Angeles International Airport, Marina del Rey is situated in an unincorporated area of Los Angeles County. Today, its population is approximately 10,000 permanent residents. The seasonal day population often exceeds 30,000 people.

Celebrities—from film stars to scientists, artists and authors—have frequented Marina del Rey over the years. Among them were the cast and crew of *Baywatch*, a popular television series that first aired in 1989, and *The Flying Nun*, a television sitcom that aired from 1967 to 1970. Another notable was the undersea explorer and inventor Jacques Cousteau, whose aqualung invention enabled divers to study the sea and all its forms of life and to share the ocean's beauty with the world.

And Marina del Rey is always changing. Plans for future redesign and development are constantly proposed and reviewed, reflecting the needs and demographics of the community. The County of Los Angeles Department of Beaches and Harbors maintains oversight. Future development is reviewed by the California Coastal Commission, Marina del Rey Local Coastal Plan (LCP), and County of Los Angeles Department of Regional Planning. Public hearings are conducted on the projects, amenities, and activities that the public would like to see or not see in the marina. This "Visioning Process" is considered by many to be an extension of the 1938 feasibility study.

Although Marina del Rey opened in 1962, the official dedication was made on April 10, 1965, heralding the resultant success of community action. A unique partnership of public and private enterprise emerged from the purposeful vision to provide Los Angeles citizens with a man-made

marina, economically self-sustaining, for recreational boating and other activities. In fact, Marina del Rey has exceeded the economic premise foretold in the 1938 feasibility study and is considered the "Crown Jewel of Los Angeles County." The marina is the county's largest money-generating entity, outside of homeowner taxes, creating revenue that benefits all of the county's residents.

Reflecting the diligent scrutiny maintained by the County of Los Angeles, long-tenured supervisor of the Fourth District Don Knabe, elected in 1996, led the board of supervisors in June 2013 to approve his history-making motion to return a greater portion of the monies generated by marina businesses back to the marina to support infrastructure maintenance and upgrades. Increased dollar allotments and percentage schedules of ongoing funding will ensure that Marina del Rey stays dynamic and up to date with projects that improve the quality of life for residents, boat owners, and visitors alike.

April 10, 2015, will mark the 50th anniversary of Marina del Rey's official opening. Among the planned celebrations are music, boat rides, community events, and historical reminders to all of the people of Los Angeles that Marina del Rey is for all of them, built for their recreational enjoyment. Its outstanding success as a water-sports mecca, residential haven, and economic resource has created tremendous community pride in this world-class harbor.

One

MARSHLAND, PORT BALLONA, OIL, MUD LAKE, HOPPYLAND

This handwritten document, signed on September 20, 1886, by Oscar Macy, details an agreement with the Santa Monica Railroad Company to construct a wharf and dock at "Ballona Lake" to connect it with the Pacific Ocean for foreign exports of the Atchison, Topeka & Santa Fe Railway. Macy was chairman of the board of supervisors of the County of Los Angeles. (Courtesy of Tom McMahon.)

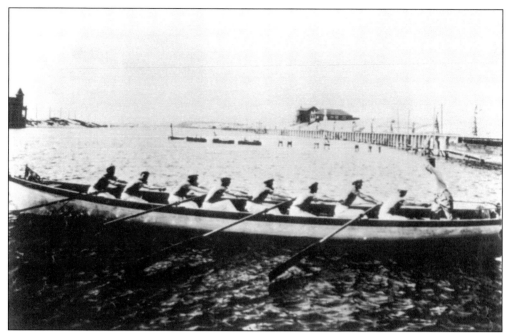

Real estate speculator Moye L. Wicks organized the Ballona Harbor and Improvement Company and built the wharf in September 1887, but he ran out of money to complete the project, declaring bankruptcy. Winter storms destroyed the wharf in 1889, rendering the site once again a marshland, suitable for duck hunting and fishing. The Ballona Lake/Lagoon became a popular rowing area. (Courtesy of SPNB Collection.)

The meandering Ballona Creek, with estuaries changing course with every storm, was a sportsman's heaven. This 1880s photograph shows Centinela Creek emptying onto the tidal plain of the Pacific Ocean and Ballona Creek. Sand dunes can be seen in the distance, and the Santa Monica Mountains are in the background at right. The distance to the creek's source is approximately 7.6 miles. (Courtesy of SPNB Collection/H.F. Rile.)

Squatters were attracted to the lagoon into the late 1890s. One story tells of an enterprising shopkeeper who set up a shack where fishermen and duck hunters could rent small boats. Successor businesses were deterred by heavy rains and storms. Duck blinds were mixed in with squatters' shacks until the US Army Corps of Engineers contained the creek by means of concrete walls in 1936. (Courtesy of SPNB Collection.)

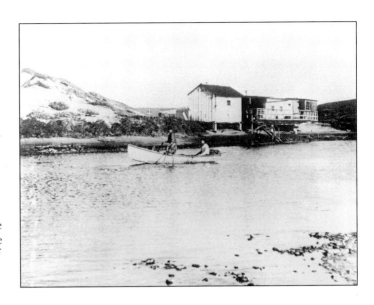

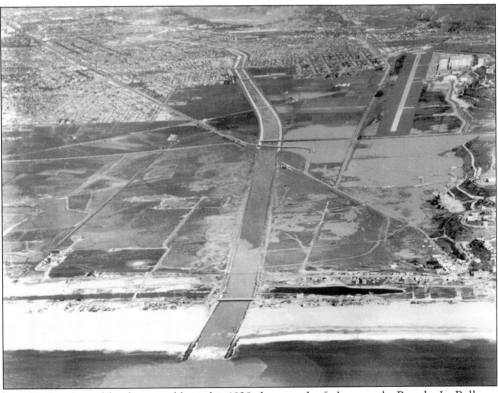

Farmland and marshlands are visible in this 1938 photograph of what was the Rancho La Ballona, a Mexican-Spanish land grant owned by Ygnacio and Augustin Machado. The area comprised 13,900 acres. The future site of Marina del Rey is to the left of Ballona Creek canal; Ballona Lagoon is now contained to the right, adjacent to the sandy beaches of the Pacific Ocean. (Courtesy of LACFD.)

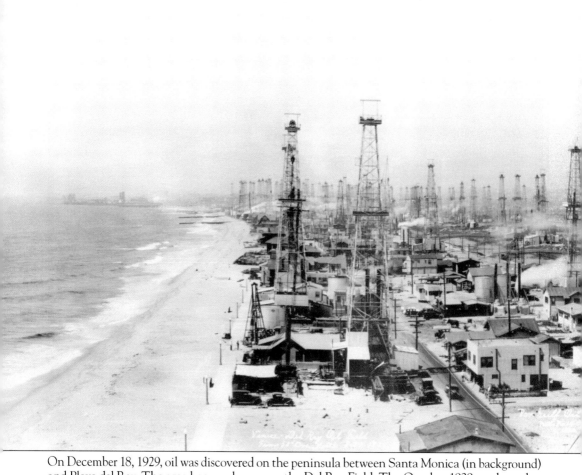

On December 18, 1929, oil was discovered on the peninsula between Santa Monica (in background) and Playa del Rey. The area became known as the Del Rey Field. The October 1929 stock market crash had rendered many speculators penniless, but suddenly, hundreds of men were employed in the oil fields of Venice. People were making money, and real estate speculation was robust. The oil fever gripping Venice and the peninsula had to be contained. The number of oil wells was

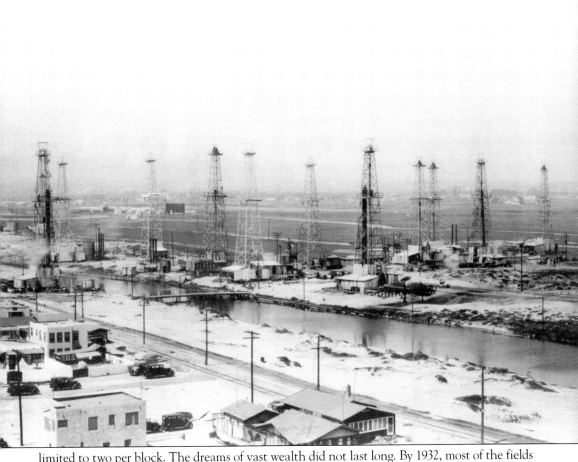

limited to two per block. The dreams of vast wealth did not last long. By 1932, most of the fields were nearly depleted, and production dwindled to a very few wells. The oil residue blighted the marshlands, promoting a breeding ground for mosquitoes. It became very costly for Los Angeles County to control the mosquito infestation. (Courtesy of MDRHS.)

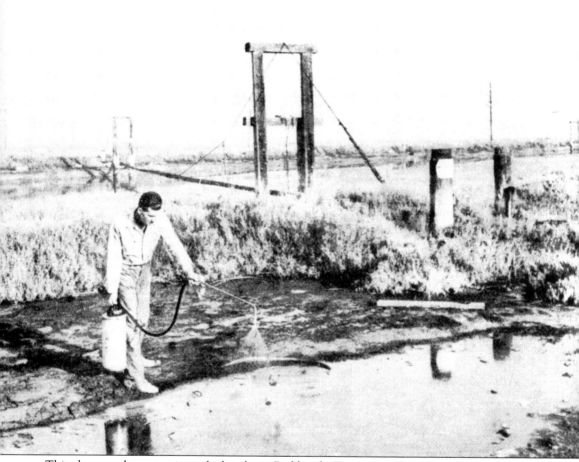

This photograph appears in a sales brochure, *Building for Tomorrow: The Community Improvement Program of Los Angeles County*, produced by Los Angeles County to describe the impending construction of Marina del Rey in the mid-1950s. The caption reads: "Money down the slough . . . More than $27,000 is spent annually to curb the mosquito menace in this now uninhabited and useless tidal marshland in Venice, destined to soon become one of the finest small boat harbors on the California coast. Construction of the Marina is slated to start next spring when the U.S. Corps of Engineers will build navigational installations at the mouth of the harbor on Santa Monica Bay. Wade Parkman, an employee of the Ballona Creek Mosquito Abatement District, is shown spraying one of the many sloughs that abound in this 1,000 acre site." (Courtesy of County of Los Angeles.)

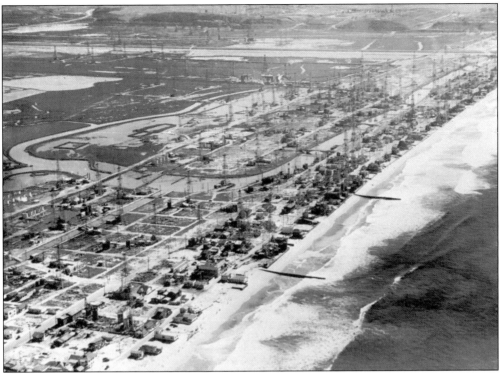

The above photograph, with a view looking south from the Pacific Ocean, shows the area now known as Marina Peninsula. It was a mass of oil wells and storage tanks, many nonproducing, mixed among older beach houses. At left, the Grand Canal separating the peninsula from today's Silver Strand—now an upscale residential area—flows farther east, then south into wetlands that would later become navigable water channels, Basins A–H of Marina del Rey. The bluffs of Playa del Rey appear in the distance, along the top of the photograph. The below photograph, with a view facing north, shows the right bend of the Grand Canal as it heads in an easterly direction. A connecting bridge is visible to the right of center. Both photographs were taken around 1938. (Both, courtesy of LACFD.)

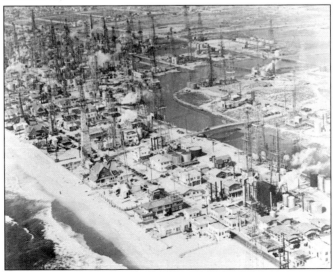

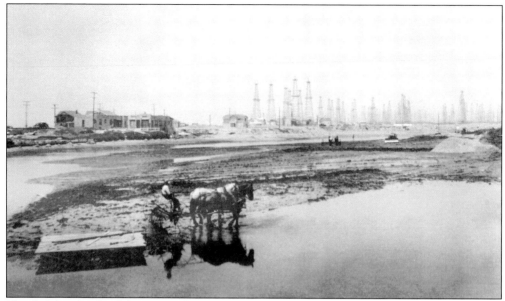

Flooded farmlands of the Marina/Venice peninsula in the early 1930s were tilled to promote drainage in order to grow celery, beans, and other produce for which this area was known. Pictured in this early photograph is farm equipment using true "horsepower" for soil-grading platforms. Early bulldozers redistribute soil dislocated by recurrent rainstorms. An abundance of oil wells of the era is viewed in the background of the picture. (Courtesy of SPNB Collection.)

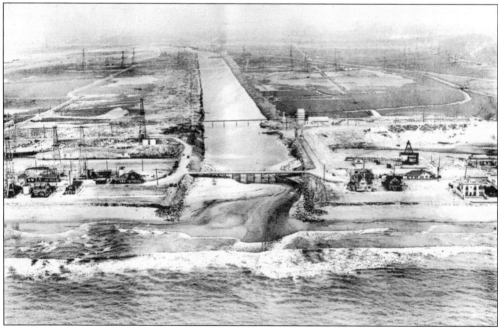

Sand buildup is seen in the exit mouth of Ballona Creek from the wetlands. Dredging was required to keep water from backing up and flooding the area. Two travel bridges cross the creek. In the center left of the photograph, three oil wells are evident. These were the final derricks; they were removed, and the wells were capped, before the main channel dredging could begin. This photograph was taken in 1937. (Courtesy of LACFD.)

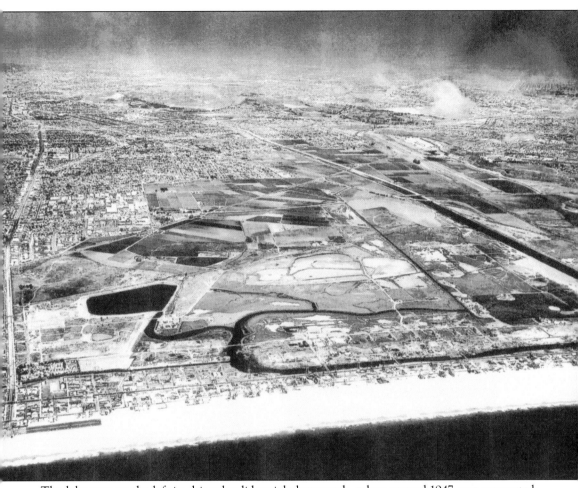

The lake area on the left in this splendid aerial photograph, taken around 1947, was connected to the Grand Canal. Lake Los Angeles, nicknamed "Mud Lake" because of its relatively shallow depth, became a popular site for picnics, water-skiing, sailing, horseback riding, and filming motion pictures. While sports activities were happening there in the 1940s and 1950s, the Los Angeles County Board of Supervisors and the Army Corps of Engineers were reviewing previous feasibility studies of building a harbor in the Playa del Rey Inlet, the earlier Port Ballona marshlands acreage. A 1938 updated study clearly supports the economic viability of a recreational small-craft harbor since the Port of Los Angeles in San Pedro became the big commercial ship/tanker wharf facility. Most of the proposed site was in unincorporated county territory; acquiring the few necessary land lots was not considered an obstacle. Besides, the land was so mosquito-infested and smelly from oil residue, sellers were eager to cash out. (Courtesy of LACFD.)

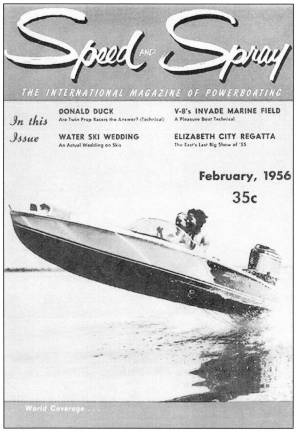

Early-1950s television productions filmed water-skiing events and powerboat races on Lake Los Angeles, as shown on this February 1956 magazine cover. The below photograph, taken by a Goodyear blimp, is labeled *T-V Rodeo*. In the photograph, boating activities are well under way on the largest body of water among the swamps, canals, celery fields, and wetlands that existed before Marina del Rey. Lake Los Angeles was the place to swim, sunbathe, water-ski, or go horseback riding at the nearby stables. The Lake Los Angeles Recreation Center was operated by Walter Leroy "Roy" Willette, a former cowboy and stuntman. Riding horseback along the lake's beach, Willette would occasionally tow a water-skier across the lake, a stunt that made its way onto the television show *You Asked for It*. With plans under way for the creation of Marina del Rey, Willette's lease ended after the summer of 1959. (Both, courtesy of *Speed and Spray*.)

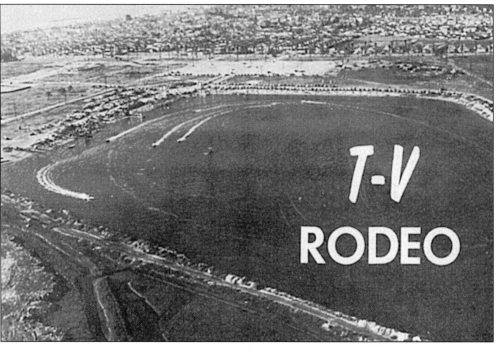

William Boyd (second from left), known for his role as Hopalong Cassidy, the most famous cowboy of the 1940s and 1950s, opened an amusement park, Hoppyland, at the site of the Lake Los Angeles Recreation Center in May 1951. The park featured a roller coaster called Little Dipper, a merry-go-round, a miniature train, and lagoon boat rides, as well as a pony ride operated by Walter Leroy Willette (third from left). Marge and Vern Willette (right) enjoyed the opening day. (Courtesy of Laura Willette Miller and Donna Willette Wooley family collection.)

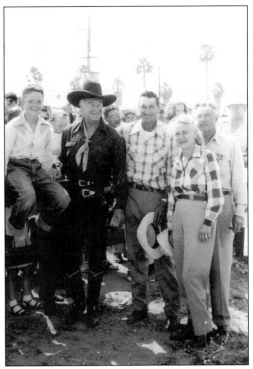

The pony rides and other amusements were not profitable enough to keep Hoppyland open, and the park closed in 1954. The lake became a public beach as part of the new project, Marina del Rey Small Craft Harbor, which was now firmly in the planning stages. (Courtesy of Laura Willette Miller and Donna Willette family collection.)

A summer day in 1957 at Lake Los Angeles finds eight-year-old Vernon Willette (left) and his buddy, Leroy Blair, twelve, hanging out at the beach. They may be getting ready for a dip in the water or they may be headed to Willette's Riding Stables, next to the lake. (Courtesy of Laura Willette Miller and Donna Willette Wooley family collection.)

Popular for sand castle creations, the lake became Mother's Beach in the new Marina del Rey harbor. The lake continues to provide protected beach and water access for all, including ramps for the disabled. (Courtesy of LACDBH.)

Two

Vision, Ground Breaking, Water Infrastructure

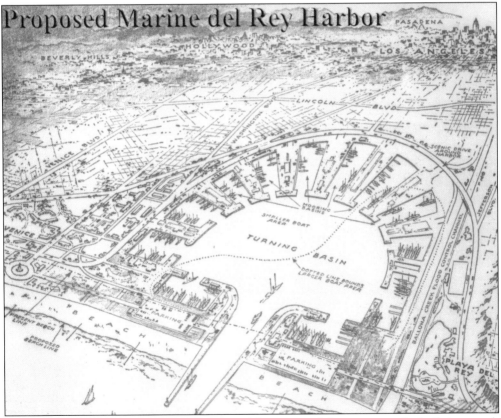

Los Angeles County engineers drew up several footprints of the marina, to be built just north of Ballona Creek. The original "Playa del Rey Harbor" map dated 1947 shows a circular design, with basins and docks arrayed around the perimeter and dirt disposal for mole development. The US Army Corps of Engineers 1955–1956 revised plan for Marina del Rey Harbor considered prevailing winds and angled the entrance channel to keep heavy seas from reaching moorings. (Courtesy of Tom McMahon.)

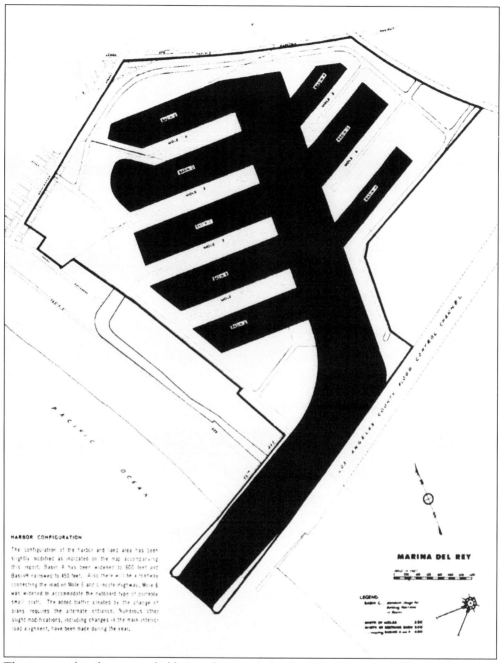

This image, taken from a map bidder's package, includes the following caption: "The configuration of the harbor and land area has been slightly modified. Basin A has been widened to 600 feet and Basin H narrowed to 450 feet. Also there will be a roadway connecting the road on Mole 6 and Lincoln Highway. Mole 6 was widened to accommodate the outboard type of portable small craft. The added traffic created by the change of plans requires the alternate entrance." (Courtesy of US Army Corps of Engineers.)

On January 21, 1954, the chief administrative officer of the County of Los Angeles, Arthur J. Will (pictured), and field deputy Rex Thomson wrote a five-page letter to Congressman Gordon McDonough, requesting federal help to eliminate a blighted area and build a small-craft harbor. A Western Union telegram (below) was received by Thomson five months later and taken to Burton W. Chace. A second, later telegram confirmed approval of the Marina Del Rey Project by the House of Representatives on July 16, 1954. (Both, courtesy of LACDBH, 1954.)

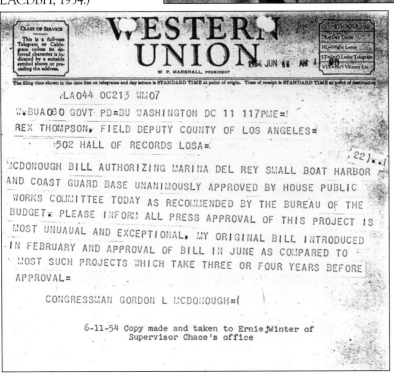

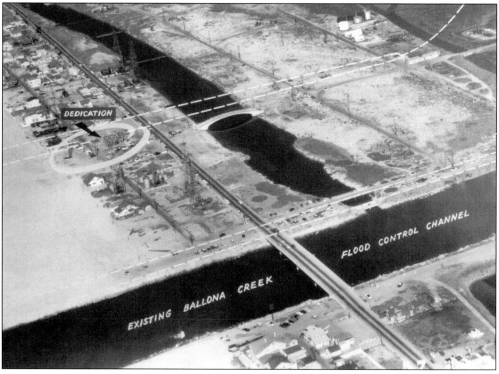

The circle at left, at the beach, indicates the group of dignitaries participating in the long-awaited ground breaking for the marina. The dotted white lines show the location of the entrance channel. The mammoth job of dredging the basins and reinforcing the bulkheads and seawalls has begun! (Courtesy of LACFD.)

```
                GROUNDBREAKING PROGRAM

            THE LOS ANGELES COUNTY MARINA del REY

10:30 a.m. Wednesday            Avenue 56 and Ocean Walk
December 11, 1957                   Venice, California

                    Francis M. McLaughlin
                    Master of Ceremonies

WELCOMING REMARKS

INVOCATION
            Rt. Rev. Msgr. Edward Wade, Pastor
            St. Mark Catholic Church
            Venice

FLAG CEREMONY
                        SEA SCOUTS of

            Ship No. 121, Culver City    Ship No. 104, Venice
            Donald Jones, Skipper        John Maxwell, Skipper

PLEDGE OF ALLEGIANCE TO THE FLAG

INTRODUCTION OF GUESTS

READING OF SCRIPTURES
            Rev. Richard N. Vos, Pastor
            Pacific Presbyterian Church
            Playa Del Rey

GROUNDBREAKING MESSAGE
            Hon. Burton W. Chace, Chairman
            Los Angeles County Board of Supervisors

BENEDICTION
            Rabbi Hershel Lymon
            Temple Akiba
            Culver City

BENEDICTION
```

The dedication took place on December 11, 1957, at Avenue 56 and Ocean Front Walk in Venice, California. Francis McLaughlin was master of ceremonies; Sea Scouts presented colors and the pledge of allegiance; Hon. Burton W. Chace gave the ground-breaking message in the presence of several religious leaders. Connolly-Pacific Company of Long Beach began construction. (Courtesy of LACDBH.)

Marina del Rey's north and south jetties were built with rocks carried by barges from a Catalina Island quarry, 26 miles away. The barge and crane are visible in the center of this 1958 photograph. The jetties lined the entrance channel into the Pacific Ocean prior to the dredging. The south jetty was an extension of the Ballona Creek exit into the ocean. (Courtesy of LACFD.)

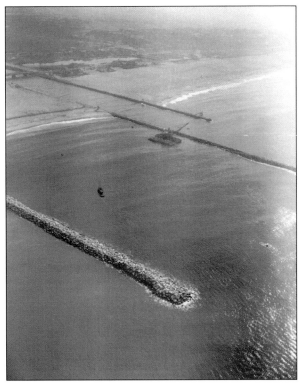

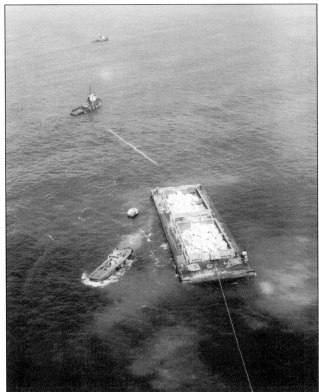

The US Army Corps of Engineers oversaw construction of the north and south jetty walls, containing the main channel. Large barges filled with boulders were towed from Catalina Island. Tugboats in the convoy ensured that the barges made the journey without incident. The giant crane stacked the rocks so as to reduce wave action for boats entering the harbor. This photograph was taken in 1958. (Courtesy of LACFD.)

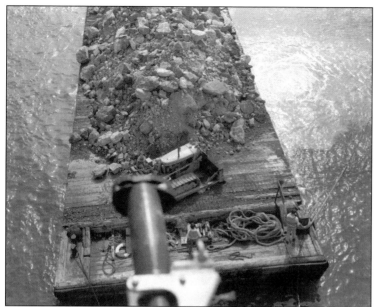

The volume of rocks and the size of the barge are evident, compared to the bulldozer traveling on the barge and the almost invisible persons handling the towlines. A portion of the dredge hose is seen in this 1958 photograph. (Courtesy of LACFD.)

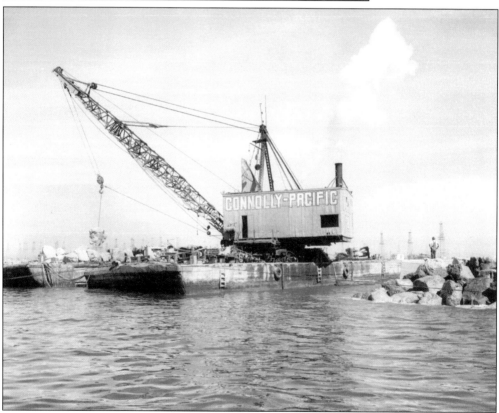

A large crane hoists rocks off the barges as it builds the north jetty and extends the south jetty. Known for quality construction of docks and wharves, Connolly-Pacific Company of Long Beach, California, was awarded the contract for the Marina del Rey water infrastructure. This photograph is dated October 16, 1958. (Courtesy of LACFD.)

In the photograph to the right, another huge crane on the north jetty lifts rocks into place, completing construction prior to the actual start of dredging the sand and ocean bottom between the jetties. In the photograph below, a dirt berm and dam are being constructed between Ballona Creek and the north jetty to continue traffic between Venice and Playa del Rey while the entrance channel and main channels are being built. The Pacific Ocean is contained to the beach line while the entrance channel, east of the berm (center foreground), is dredged. Pre-dredge seawall construction is evident in the right half of the photograph, taken in 1958. (Both, courtesy of LACFD.)

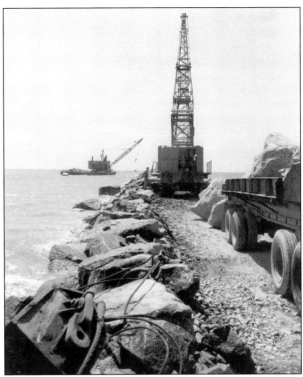

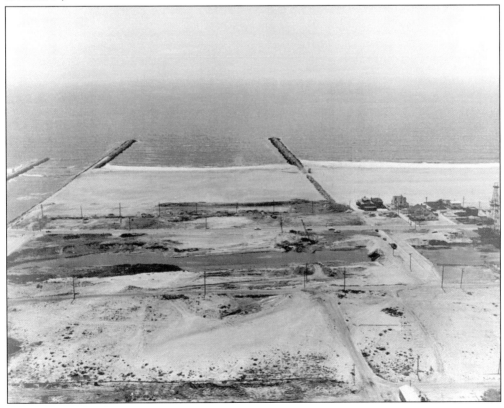

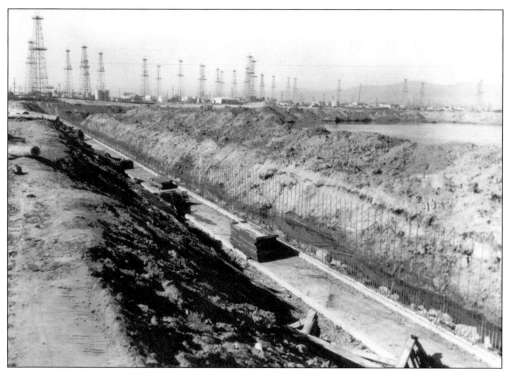

Trenches are being dug for anchors of reinforced concrete seawalls and dams to prepare for gradual excavation of the enclosed basins. In this 1959 photograph, mounds of earth are heaped to one side. Oil derricks are visible in the background. Most of them are no longer producing wells, and they will be removed as dredging and seawall construction progresses. (Courtesy of LACFD.)

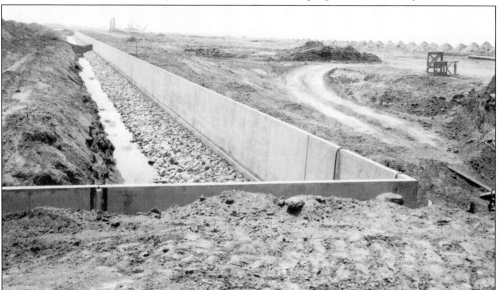

Seen here in 1960, the concrete reinforced bulkhead is complete in this section. The dirt materials are ready to be dredged. The natural sea level of the seeping water table is evident. Rock riprap has been poured at the base of the bulkhead to strengthen and mitigate wave action against the seawall. (Courtesy of LACFD.)

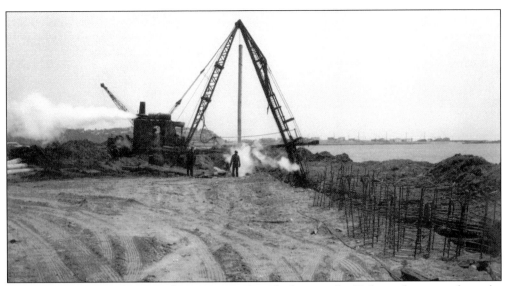

As the trenching for the seawalls continues, the pile driver sinks 30-foot piles to reinforce the bulkheads at each basin. There were 7,500 piles driven on the basin perimeters. The main channel waterway has been partially dredged in this 1960 view looking south toward the Playa del Rey bluffs. (Courtesy of LACFD.)

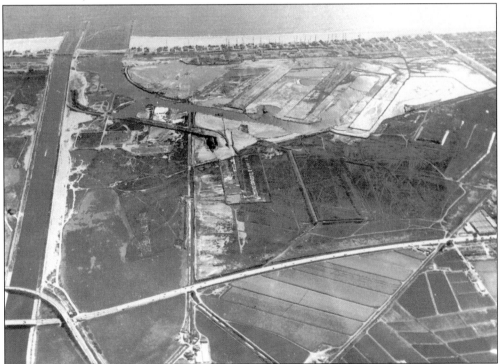

The Ballona Creek channel is at the left in this 1960 photograph. The main channel is at the top left, with ocean water on both sides of the Pacific Avenue berm. Dredging of the inner entrance, main channel, and side basins has now begun. The faint white lines in the center of the photograph are footprints of the concrete seawalls being built to the configuration of the harbor. (Courtesy of LACFD.)

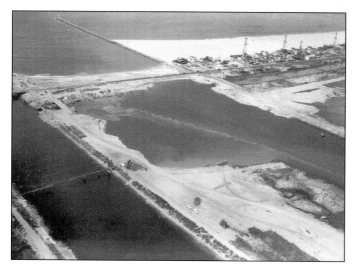

A few oil wells are still standing on Pacific Avenue in 1960. The roadway is connecting to the Ballona Creek Bridge, and more of the entrance channel has been dredged. Dirt roadways are intertwined throughout, as mud and sediment continue to be relocated. It is estimated that the volume of dirt relocated in the building of the marina would fill over eight Los Angeles Coliseums. (Courtesy of LACFD.)

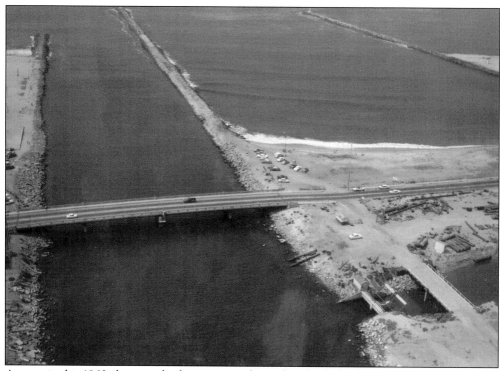

As seen in this 1960 photograph, the entrance channel is clearly dredged between the north and south jetties. Pacific Avenue is still connected by roadway over the berm and onto the bridge over Ballona Creek going south (left) into Playa del Rey. The Grand Canal of the former Venice canal system is being fitted with sluice gates (lower right corner) to allow tidal action to flow into the canals still extant in the city of Venice. Sluice gates allow ocean water to enter the dredged entrance channel. (Courtesy of LACFD.)

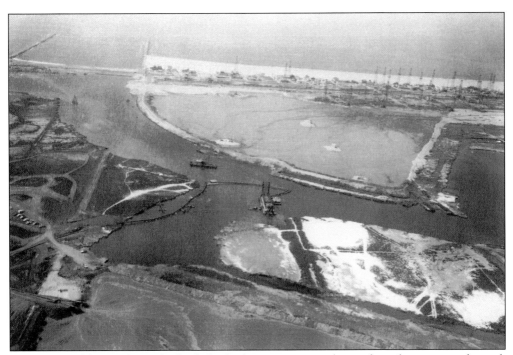

In this view of the area being dredged, the dredger pumps out sediment from the entrance channel. Basin A (center right) has been partially dredged in this September 1960 aerial photograph. The earth-water slurry is being discharged through the hoses to specific areas, which will become earthen moles, filled and modified for land development with utilities, sewers, and roads. Marina del Rey harbor is becoming a reality. (Courtesy of LACFD.)

This 1960 photograph offers a view of the "suction dredge." This device pumps its mixture of mud and water through movable pipes, which then deposit the slurry into shoreside pools, where the earth settles to the bottom and the water is drained off the top. This process removes the earth from the channels contained by earlier seawall construction. The deposits build up land for mole development. (Courtesy of LACFD.)

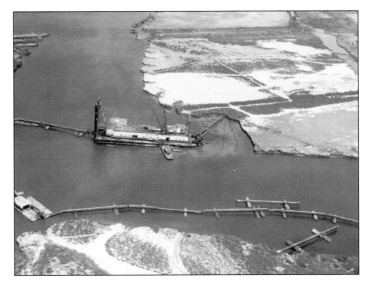

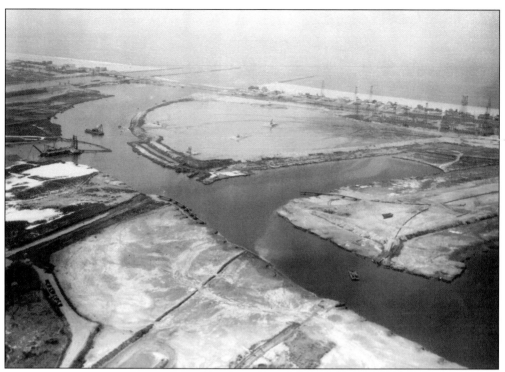

The view in this 1960 photograph faces west to the Pacific Ocean. The dredging process has progressed up Basin A. The future fuel dock is at the corner site of the upper landmass (center). A few oil wells remain on the peninsula. (Courtesy of LACFD.)

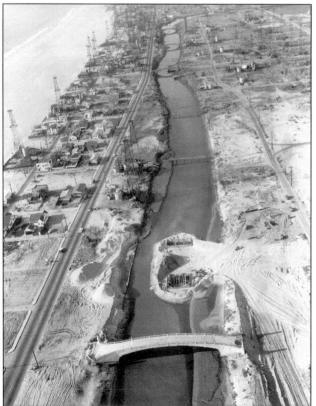

In order to maintain adequate tidal action and ocean flow into the Grand Canal, which will now open to the ocean through the harbor entrance channel instead of via Ballona Creek, two oil wells were removed and capped. In this 1959 photograph, the two coffer dams (circle area) are adjacent to the Lighthouse Bridge (center bottom) connecting the peninsula with the marina development. (Courtesy of LACFD.)

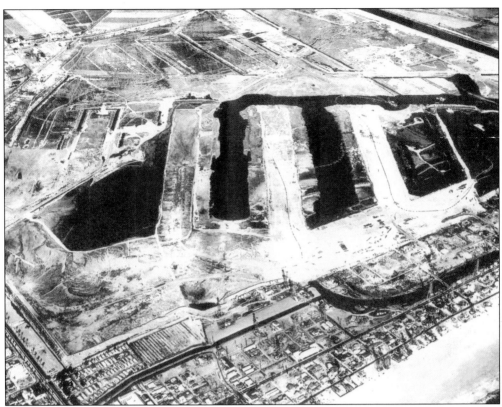

Shown here being dredged around 1960 are, from left to right, Basins D, C, B, and A. Basin D has much the same shape as Mud Lake in the 1940s and 1950s. That area will become Marina Beach, nicknamed "Mother's Beach." More sand will be brought in to create a family-oriented protected beach and small-boat sailing area. A very faint outline of the concrete seawall perimeter around the basins toward the top of the photograph indicates the planned footprint of Marina del Rey, still to be dredged. (Courtesy of LACFD.)

Mother's Beach was created with additional sand. Sailboats are visible on the water in this 1962 photograph. The mole between Basins D and E has a roadway, Palawan Way, and boat docks under construction. The docks at far left have boats berthed in Basin E. (Courtesy of LACFD.)

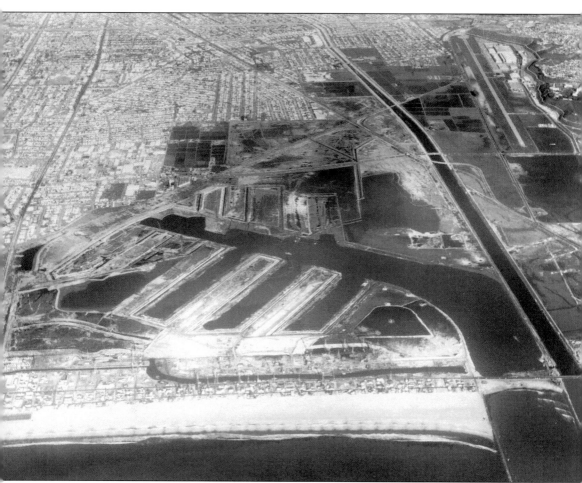

This 1961 aerial photograph shows the dredged main channel, running from the Pacific Avenue berm (lower right) to the north head wall boundary of the marina (left of center). Basins E and F have visible perimeter outlines made by earlier construction of the seawalls, where dredging will take place. The photograph shows that the marina has eliminated much of the marshlands to the north (left) of Ballona Creek, which runs from lower right to middle top of picture. Wetlands remain on the south side (right). The city side of the marina has yet to be dredged. The Westside area of Los Angeles is beginning to fill with residential and commercial properties. The connecting roadway from Pacific Avenue over the entrance channel via the bridge over Ballona Creek is evident. (Courtesy of LACFD.)

The Union Oil fuel dock, built on the corner of A Basin and the main channel "turning basin," could accommodate 24 vessels at one time. It claimed to be the world's largest pleasure-craft fuel dock. Bora Bora Way (paved road left of center) connects to Via Marina Way at the top of the frame. Some original oil derrick structures are visible in the background. This photograph was taken in 1962. (Courtesy of LACFD.)

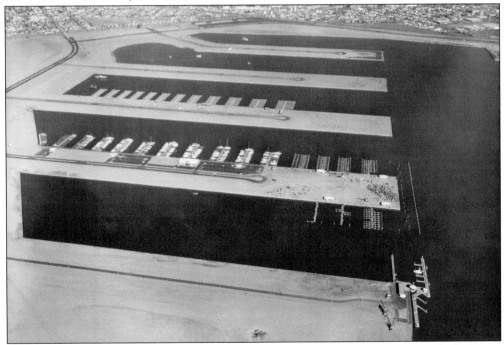

In this view looking north in 1962, five basins are complete. They are, from front to back, Basins A–E. Basin B shows "fingers" extending from the north side. This is the first marina opened, Westside Marina, in September 1962. In Basin C, the fingers of Villa del Mar Marina are being established. Via Marina roadway (upper left) is angling into Admiralty Way (top). (Courtesy of LACFD.)

The first structures built in 1962 in Marina del Rey included the Los Angeles County (LAC) Administration Center for the director of Marina del Rey, his staff, and their planners. The Harbormaster's Office opened in May 1962, with docks for patrol boats. The US Coast Guard station shown here was under construction at the same time as the Harbor Patrol station. (Courtesy of LACDBH.)

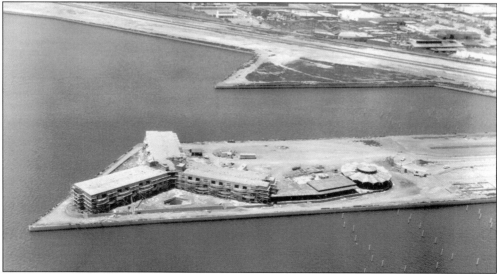

The Sheraton hotel opened in August 1962. It suffered financial shortfalls in the early years, coincident with the storm surge problems, and then declared bankruptcy. The hotel leasehold was purchased, and the establishment was renamed Marina del Rey Hotel in the late 1960s. (Courtesy of LACDBH.)

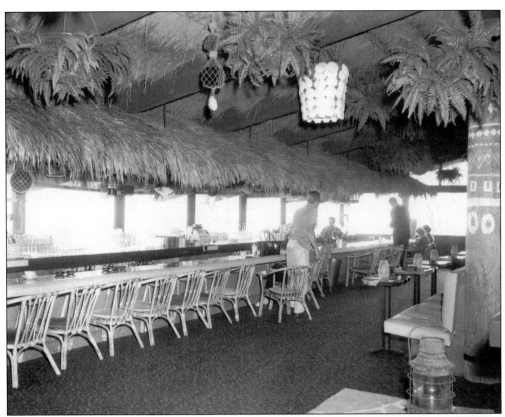

Pieces of Eight restaurant (above) was built next to the Harbor Department on Fiji Way. The streets in Marina del Rey are named for tropical Pacific Ocean islands. The restaurant's tropical decor, food, and exotic drinks were unique to the area at the time, making Pieces of Eight very popular. In the early 1960s, Capt. Long John Silver (right), dressed in pirate's costume and peg leg, stood on Lincoln Boulevard by the unimproved roadway leading to the restaurant, beckoning diners to the water's edge of the newly opened marina. He was a public-relations boom, as motorists were captivated and drawn to visit the new marina. (Both, courtesy of LACDBH.)

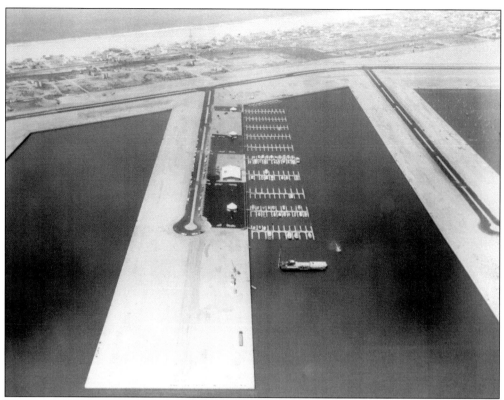

The water infrastructure was completed in 1962. The dredging operation left the marina in December 1962. Recreational sailboats and powerboats moved into the new Westside Marina, Parcel 36, in August. Boat owners from other Southern California marinas brought their craft to the new marina, happy to be closer to home. Among the new tenants was Commodore William DeGroot, who was also a commissioner for California Boating and Waterways. (Courtesy of LACDBH.)

As most boat owners were optimistic about a wonderful water experience, the Del Rey Yacht Club looked to the future by building its own clubhouse on an ideal leasehold, pictured here in a 1962 dedication. The Del Rey Yacht Club signed its lease with Los Angeles County on March 27, 1962. However, the clubhouse was not completed until 1965. (Courtesy of LACDBH.)

Three

STORM SURGE DESTRUCTION, SOLUTION, SUCCESS

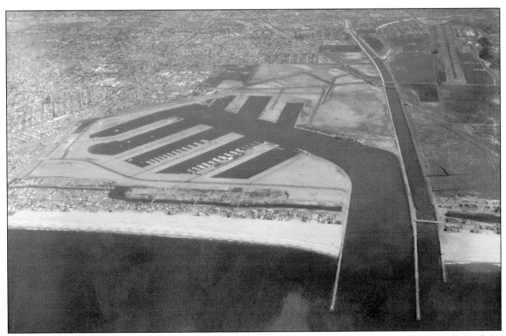

Marina del Rey was opened for business in 1962. Bidders for leaseholds were being solicited. In mid-July the same year, offshore storms subjected the marina to excessive wave action. The US Army Corps of Engineers accepted the responsibility of finding solutions to abate the energies. A scale model of the harbor was established at the Waterways Experiment Station in Vicksburg, Mississippi. The model indicated that the most extreme conditions would affect the Administration Center, while other areas would experience intense to moderate effects. In an actual weather event in mid-December 1962, Westside Marina boat owners were unhappy with the violent action of the docks brought on by severe storm surge waves. However, it was the devastating storm of January 1963 that produced heavy wave tidal damage to the Westside Marina as well as to the Harbor Administration Center and Pieces of Eight restaurant. An immediate solution had to be found. Again, the Pacific Ocean was trying to reclaim its marshlands. (Courtesy of LACFD.)

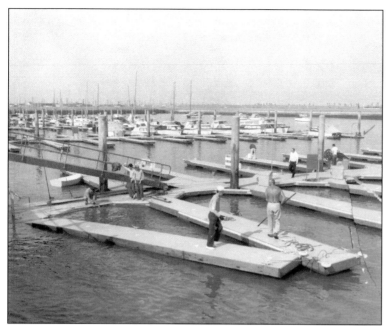

Strong storms in the Pacific Ocean, hundreds of miles offshore, create wave action that funnels strongly into Santa Monica Bay. In January 1963, a violent surge upended docks, pilings, and utilities, as shown here. Boats were removed from the Westside Marina, which was closed on February 11, 1963, until the docks were repaired. (Courtesy of LACDBH.)

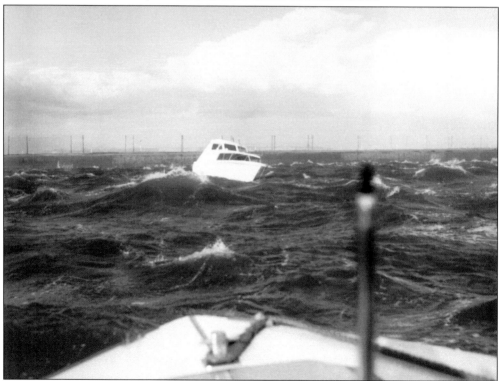

Vessels were anchored in the center of the marina to escape damage. The photographs on the next five pages are reproduced from the November 8, 1968, issue of *Dinghy* magazine, which revisited "the Big Surge." Publishers Ed and Betty Borgeson later sold the marina's only boating publication to Darien Murray and Greg Wenger. *Dinghy* ceased publication upon Murray's death in 2002. (Courtesy of LACDBH, 1963.)

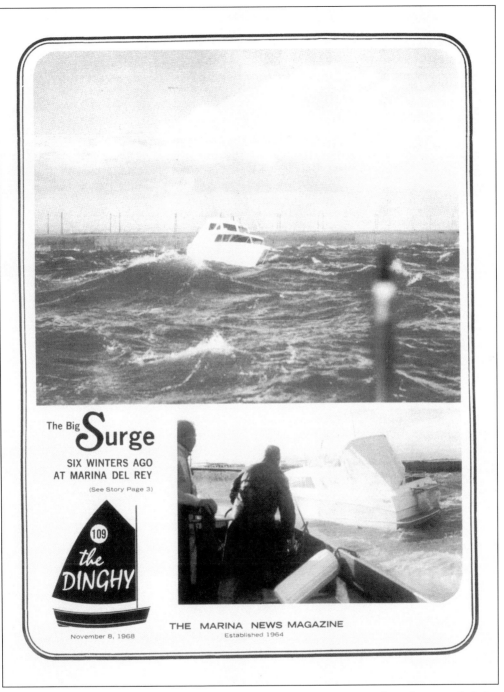

The November 8, 1968, issue of *Dinghy* recaps the devastating surge that almost ended the establishment of the new Marina del Rey harbor. The article begins, "Six years ago, in the winter of 1962–63, the fledgling Marina del Rey harbor was beset by what has since become known as 'the Surge.' Large and rapid swells built by distant tropical storms far down the coast of Mexico, which once every 50 years or so make a direct hit on our local coastline, drew a bead that winter on the unprotected mouth of the new Marina channel." (Courtesy of MDRHS.)

THE SURGE

Six years ago, in the winter of 1962-63, Marina del Rey was beset by what has since been called "the surge." Large and rapid swells built by distant tropical storms far down the coast of Mexico, which once every 50 years or so make a direct hit on our local coastline, drew a bead that winter on the unprotected mouth of the new Marina channel.

Height of the advancing surge along a bulkhead in basin A at Caballo del Mar (later renamed Tahiti Yacht Landing) can be seen in top photo. The kind of damage done to slips here and at the newly completed Westside Marina (now Imperial Harbour) is shown in lower photo.

As the winter weather worsened, the damage continued. In January, 1963, all remaining docks in the Marina were ordered vacated and a Santa Monica contractor was hired to install moorings for the Marina's few remaining boats.

(Continued on page 10)

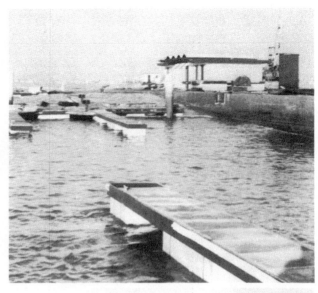

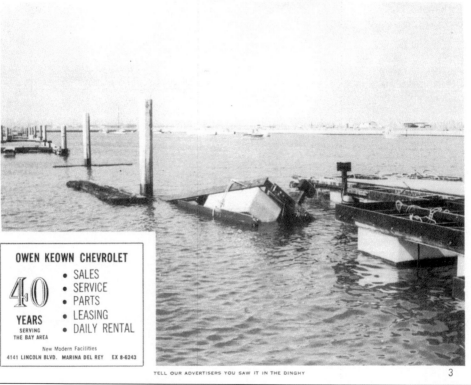

OWEN KEOWN CHEVROLET

40 YEARS SERVING THE BAY AREA

- SALES
- SERVICE
- PARTS
- LEASING
- DAILY RENTAL

New Modern Facilities
4141 LINCOLN BLVD. MARINA DEL REY EX 8-6243

TELL OUR ADVERTISERS YOU SAW IT IN THE DINGHY

The height of the advancing surge along the bulkhead in Basin A at Caballo del Mar (later renamed Tahiti Yacht Landing) is shown in the top photograph. The kind of damage done to the slips here and at the newly completed Westside Marina is shown in the bottom photograph. (Courtesy of MDRHS.)

THE SURGE Continued

CARL D. HUNT AGENCY
YACHT
Insurance
for MARINE OFFICE OF AMERICA
13645 Fiji Way, Marina del Rey
823-4581

Chuck's of Hawaii **STEAK HOUSE**

COCKTAILS 4 PM 'til 2 AM
DINNER 5 PM 'til —

ENTERTAINMENT

**4142 VIA MARINA
• MARINA DEL REY
823-6111**

**BOAT PROTECTION
FOR 1-FULL YEAR!**

ONLY **$10**

*Don't forget to send
your check now!*

MARINA DEL REY SECURITY SERVICE
2420 Bryan Avenue
Marina del Rey, California 90291

Engine Trouble? Diesel/Gasoline

Engine Rebuilding
Motor Tune-Up
Electric Rewiring
Transmission Work
Water & Bilge Pump

Call for free estimate
823-1285 or 375-6837

**PIERRE'S MARINE
ENGINE SERVICE** Playa del Rey
All Work Fully Guaranteed

CARIBBEAN CHARTERS

Enjoy tropical island tradewind sailing year-round in beautiful newly discovered storm-free Windward Islands. First Class yachts 30 ft. to 100 ft. Bareboat or with complete crew. See us today.

**GRENADA YACHT
SERVICES LTD.**

13967 Marquesas Way,
Marina del Rey, Calif. 90291
(213) 823-4644

Yacht Management
CARIBBEAN'S COMPLETE MARINA Complete Shipyard

10

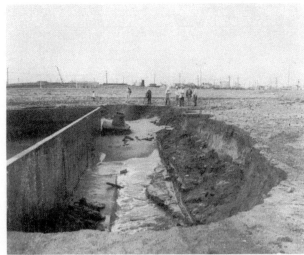

The Harbor Patrol's first boat was put in service here in April, 1962, and among its chores that winter (as shown in cover photos) was the occasional rounding up and capturing of unmanned runaway boats.

Land damage from the surge included the sucking away of fill land (top photo) at the site of what is now a part of the Marina Point Harbor apartment complex (shown from same vantage point today in lower photo).

(Continued on page 11)

TELL OUR ADVERTISERS YOU SAW IT IN THE DINGHY

Damage from the surge included the sucking away of the fill land, shown in the top photograph, at the site of what is now a part of the Marina Point Harbor apartment complex in 1968. The site is seen from the same vantage point in the bottom photograph. Note the advertisement for a full, one-year boat protection service, offered for only $10. (Courtesy of MDRHS.)

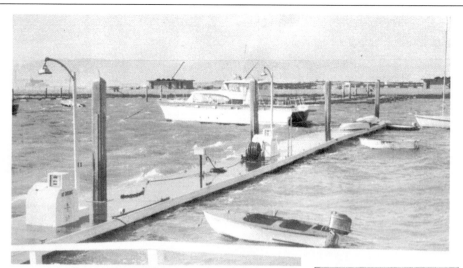

One of the largest boats moored here then (and still here) was the 55' "Cavalier IV" of California Harbor and Watercraft Commissioner William A. DeGroot, Jr. (top photo). The fuel dock shown was the Marina's second operating business (the first was Pieces of Eight Restaurant).

Basis of the emergency action that was taken to protect the Marina from future surges after that one bad winter was the scale model shown below. Built as a result of early indications of vulnerability of Marina del Rey to just such wave action as had occurred, a
Continued Page 12

Pacific Shores Realty
OCEAN FRONT — CANAL and MARINA PENINSULA PROPERTY
EX 9-3211 327 WASHINGTON ST.

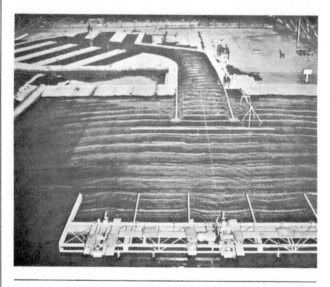

HOUSEKEEPING AFLOAT
YOUR YACHT HYGIENIST

General Boat Keeping
Teak Decks Expertly Maintained
Carpet & Drapery Cleaning
Fiberglass Boats Cleaned
& Polished
Exterior Wash-down to Waterline
Provisioning
391-1134

TELL OUR ADVERTISERS YOU SAW IT IN THE DINGHY

One of the largest boats moored was the 55-foot *Cavalier IV*, belonging to California Harbor and Watercraft commissioner William A. DeGroot Jr. The fuel dock in the foreground of the top photograph was the second business open in the new marina, following Pieces of Eight. The surge model had been well under way by the US Army Corps of Engineers, due to the vulnerability of the marina to such wave action. With the storm, the study was put on a "crash" basis. (Courtesy of MDRHS.)

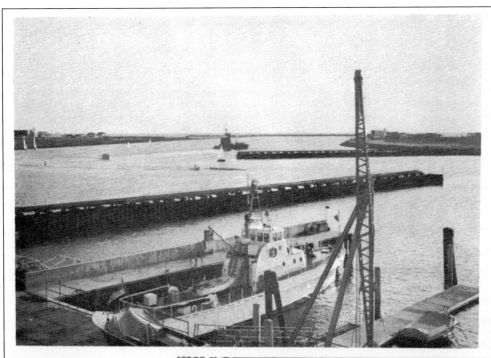

THE SURGE Continued

study of the entire project was already well underway at the U.S. Corps of Engineers Waterways Experiment Station at Vicksburg, Mississippi. The study was put on a "crash" basis.

Contrary to some very dark predictions in the press and elsewhere during early 1963 that the new Marina was already done for — that the whole thing was an amusing but fantastically expensive mistake — the solution to the problem was well begun by the following winter.

The breakwater at the end of the channel — as designed with the aid of the model in Mississippi — was begun in October, 1963. As an interim solution to the surge, while it was being built, two sheet metal groins (top photo) were installed in the main channel. These — and the last threat of surge for Marina del Rey — were removed after the completion of the breakwater in 1965.

ALLEN FURNITURE
decorative home furnishings

11954 Wilshire Blvd., W.L.A. 477-0767
1343 - 5th St., Santa Monica 394-8760

Open Monday — Wednesday — Friday Evenings until 9 P.M.
FREE PARKING • BUDGET TERMS • RUG DEPT. & BOAT FURNISHINGS

BOAT & YACHT SERVICE 654-2222 (24 Hrs.)
 467-9138 (After 6 PM)

BOATKEEPING — Washing & Polishing, General Maintenance
CARPENTRY — Complete Marine Woodwork • ELECTRICAL — Wiring & Repair Service • MECHANICAL — Minor & Major Jobs • PAINTING & VARNISHING — Full Yacht Refinishing • FIBERGLASS REPAIR — MARINE BATH INSTALLATION — • LOW PRICES •
All Work Done by Experts & Fully Guaranteed.

NAUTICAL FASHIONS FOR MEN
OPEN 9:30 to 5:30 Monday thru Saturday
Friday Evenings Until 9:00 PM

CAMPBELL'S 333 SHOP
333 Santa Monica Boulevard • Santa Monica

Very dark predictions were made in the press and elsewhere during early 1963 that the new marina was done for, that it was an amusing but fantastically expensive mistake. However, the solution to the problem was begun by the following winter. The new breakwater was started in October 1963 and completed in 1965. Temporary baffles were removed, and the marina was free from the threat of future surges. (Courtesy of MDRHS.)

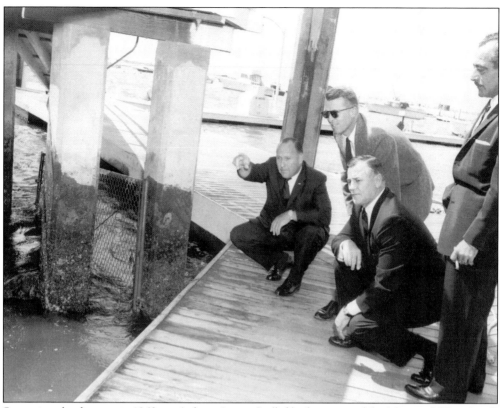

Surveying the damage in 1963 are Aubrey Austin Jr. (left), chairman of the Marina del Rey Small Craft Harbor Commission, and Art Will (second from left), director of Marina del Rey. The two other individuals are unidentified harbor commissioners. It appears that the dock and pilings have separated. (Courtesy of LACDBH.)

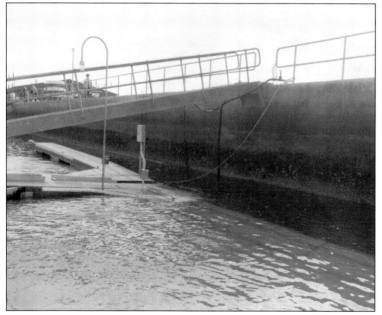

In this 1963 photograph, the gangway leading to the walkway along the finger where the boats are docked appears to be twisted. The dock under the ramp is broken and not connected to the walkway. Excessive wave action has apparently crunched the dock against the seawall and twisted it apart. (Courtesy of LACDBH.)

As seen in the above photograph, taken in 1963, the "washing machine" wave action undermined the walkway along the seawall at Pieces of Eight restaurant (right). The damage was especially intense in the area next door, where the Harbor Administration Center is located on Fiji Way (below). The severity of the surge intensified the urgency for the US Army Corps of Engineers to speed up its short-term solution for immediate prevention of more damage as well as to develop a permanent safe-harbor plan. Fortunately, both county engineers and the Corps of Engineers had already been studying previous wave and tidal actions at the Vicksburg Experimental Station and were prepared to move on a plan to build a temporary baffle system to prevent more damage while a permanent deflection breakwater was being constructed. (Both, courtesy of LACDBH.)

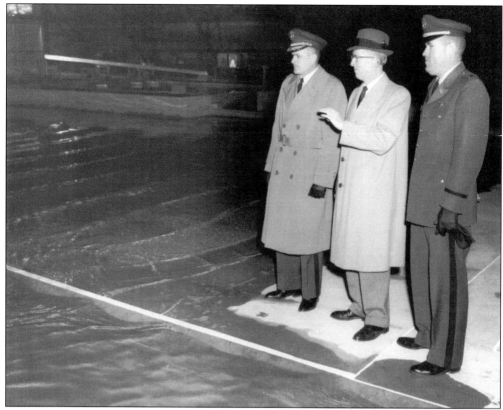

The director of Marina del Rey, Arthur Will, journeyed to Vicksburg, Mississippi, to the Army Corps of Engineers Experimental Station, where wave studies were being conducted with the tank model of Marina del Rey. Standing on a simulated mole with two unidentified Army engineers in 1963, Will (center) watches the machine-generated wave action effect on the seawalls and ponders what might be done to mitigate adverse effects. (Courtesy of US Army Corps of Engineers.)

The resulting investigative and hands-on research findings were later published in a 1993 engineer's manual. The results conclusively show that a range of wave actions could cause extensive damage in certain parts of the marina. The engineers recommend short- and long-term cures: First, install temporary sheet-pile baffles across the entrance channel; second, build a permanent detached breakwater. (Courtesy of US Army Corps of Engineers.)

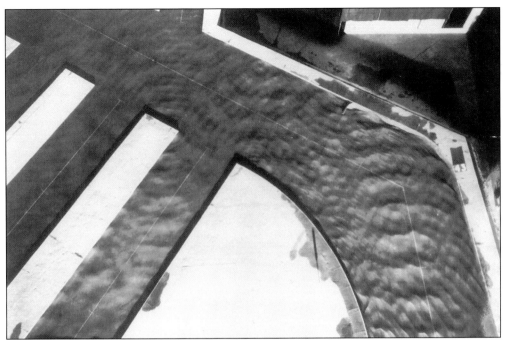

In the above photograph, the generated turbulent wave-water action damage can be noted on the area corresponding to the location of Pieces of Eight restaurant and the Harbor Administration Center. This action indeed occurred in January 1963. County files indicate that 11-second intervals with close to 15-foot waves had been recorded in previous years, which is why the model had been constructed earlier to study known wave actions. Below, the same wave-tidal action produced little to no damage on the scale model experiment when a breakwater was added to the mouth of the entrance channel. The decision was made to build a breakwater. (Both, courtesy of US Army Corps of Engineers.)

The US Army Corps of Engineers at Vicksburg also modeled the breakwater with great precision as to water-wave and tidal actions under various storm conditions. Seasonal aspects were considered. It was usual for the wave actions to be less pronounced in the summer months, so a time window came into play for the construction of the detached breakwater. (Courtesy of US Army Corps of Engineers.)

The model study without the breakwater shows wave-tidal action definitely entering the channel entrance and proceeding directly into the marina main channel. As the marina harbor is now contained by concrete seawalls, the funnel effect increases the turbulence of the water and can be destructive, as previous inner harbor studies showed. (Courtesy of US Army Corps of Engineers.)

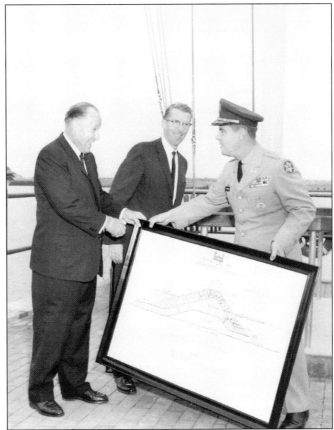

By placing the scale model under various simulated weather patterns, the optimum placement of the breakwater was determined. The wave action is virtually nil in the protected entrance channel area in the model test. The height, width, type of stone, and construction layers are specified in "The Marina del Rey Typical Breakwater Cross Section," issued by the US Army Corps of Engineers. In the photograph to the right, the framed "souvenir" edition is being accepted in 1963 by chairman Aubrey Austin Jr. (left) and marina director Art Will (center). Officer Peacock of the US Army Corps of Engineers (right) is present at this initiation of the start of construction of the detached breakwater. (Both, courtesy of US Army Corps of Engineers.)

Chairman Aubrey Austin Jr. (left), engineer officer Peacock (center), and marina director Arthur Will hold large rocks and are poised to toss the material at the spot where the new breakwater will be built. The ceremony took place on September 20, 1963, with barge No. 8 standing by. (Courtesy of US Army Corps of Engineers.)

Connolly-Pacific Company started work on October 15, 1963, after being awarded a special federal appropriation. Many Marina del Rey original leaseholders and county officials lobbied intensely to Congress and the Senate for funds. So, once again, the giant crane lifted boulders off the barge brought from the Catalina quarry, onto the new detached breakwater, as seen here in 1964. (Courtesy of LACFD.)

For temporary protection to the inner harbor, sheet-pile baffles were installed a few feet south of the US Coast Guard station and extended 450 feet into the main channel. On the west side of the main channel, but staggered about 200 to the west, another set of baffles 450 long was installed. Marina waters were placid while the detached breakwater was being built. There was plenty of room for boats to enter and leave the harbor, as seen here in 1963. (Courtesy of LACFD.)

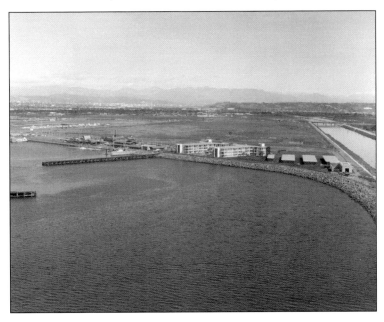

In this 1963 photograph, the baffle from the east side of the main channel can be seen jutting out of the riprap just below the residential Villa Venetia apartment buildings, under construction at the end of Fiji Way. The undeveloped areas beyond Villa Venetia are Ballona Wetlands, now a protected habitat. On the right is Ballona Creek. (Courtesy of LACFD.)

The detached breakwater is halfway finished in this 1964 photograph. Waves can be seen crashing against and over the rocks, while the crane sits in the relatively protected non–wave action leeward section. The prevailing wind is usually from the west, so the high rock formation also protects against heavy wind as boats enter Marina del Rey. (Courtesy of LACFD.)

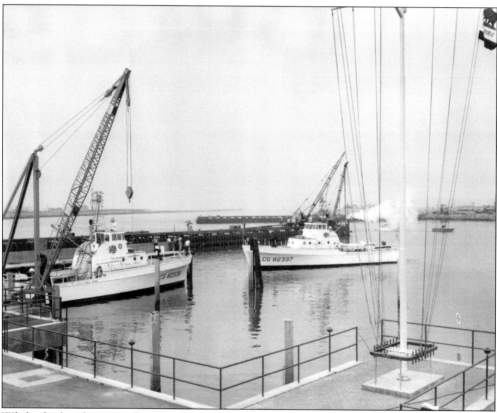

While the breakwater is being built, 82-foot Coast Guard cutters wait in readiness for water rescues or emergencies in 1964. Los Angeles International Airport is six miles to the south of Marina del Rey, with air traffic landing and taking off over the ocean. Leasehold development of the commercial and residential structures intensified after the viability of the marina had been secured. (Courtesy of LACFD.)

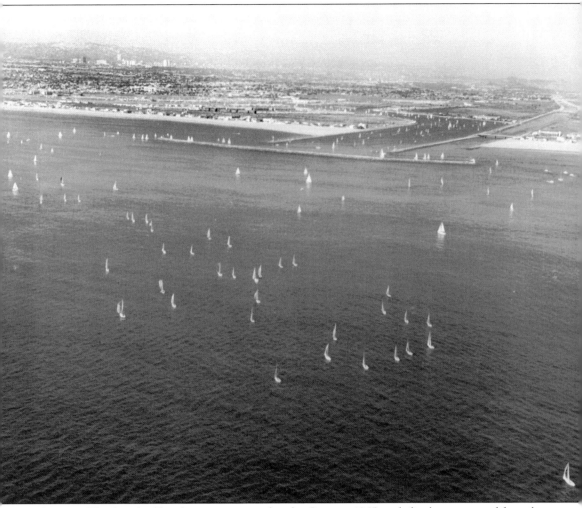

Success! The detached breakwater was completed in January 1965, with final wrap-up and formal dedication of Marina del Rey taking place on April 10, 1965. This event signaled that the facility had finally achieved its goal to be the largest man-made marina in the world. Designed for a capacity of nearly 6,000 pleasure craft berthed in water slips, the number expands to 8,000 when dry-storage boats are included. The number swells when trailer boats are launched from the public ramp. Potential leaseholders began bidding for restaurant parcels. Apartment parcels were snapped up by developers, who achieved nearly 100 percent occupancy. Seasonal day populations often exceeded 30,000. Yet to be built are several parks and public facilities. (Courtesy of LACFD.)

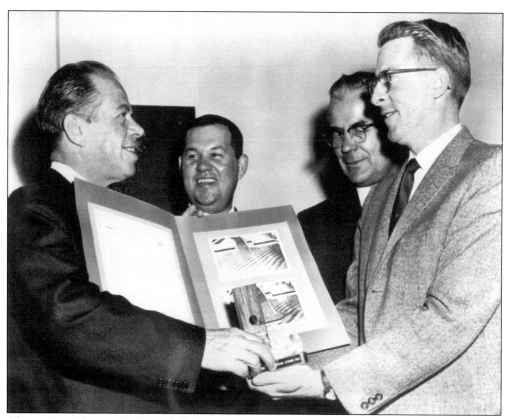

Above, Sen. Thomas H. Kuchel (left), of the California Senate Appropriations Committee, is recognized in 1964 by Los Angeles County officials for his assistance in obtaining federal funds for improvement of Marina del Rey's yacht harbor. The work helped to prevent a recurrence of wave damage experienced in 1963. Senator Kuchel was presented with a symbolic piece of rock from the first barge load deposited in the new offshore breakwater. He was also given a resolution of county appreciation, with photographs of a model of the new protective project. Shown here with Kuchel are, from left to right, Joseph M. Pollard, administrative assistant to county supervisor Warren M. Dorn; county engineer John A. Lambie; and director Arthur G. Will of the County Small Craft Harbors Department. Also instrumental in obtaining funds were Aubrey Austin Jr., chairman of the Small Craft Harbor Commission, and Jerry Epstein (below), a major Los Angeles real-estate developer of Parcels 23 and 24. (Above, courtesy of LACDBH; below, courtesy of Greg Wenger Photography.)

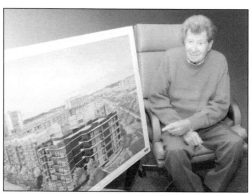

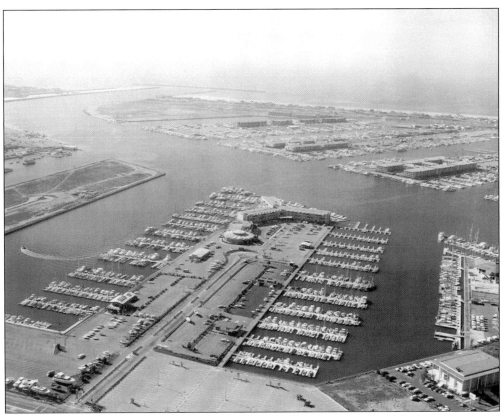

Construction of Mystic Cove Marina by leaseholder David Jennings is visible in the lower foreground of this 1965 photograph. The anchorage-only parcel suffered little damage in the storm surge because of its location deep into Basin F. The Marina del Rey Hotel (center) now has boat slips constructed on the south side of the mole. (Courtesy of LACDBH.)

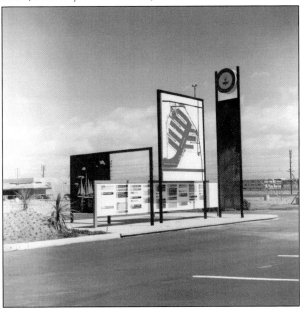

Located at the main entrances of Marina del Rey are large information standards showing the configuration of the marina and directions to the few businesses and marina anchorages already built in 1966. In order to become the world's largest man-made marina, the County of Los Angeles had to bring in developers and users. (Courtesy of LACFD.)

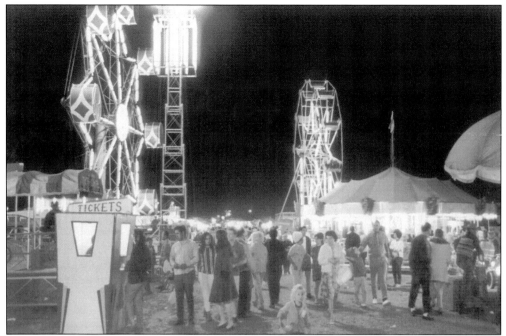

Marina "country fairs," including amusement-park concessions, food booths, merry-go-rounds, and Ferris wheels, were set up to provide a fun experience for visitors to the new marina site. Evenings and weekends were usually filled with some kind of entertainment that could take place on the empty land. (Courtesy of LACDBH.)

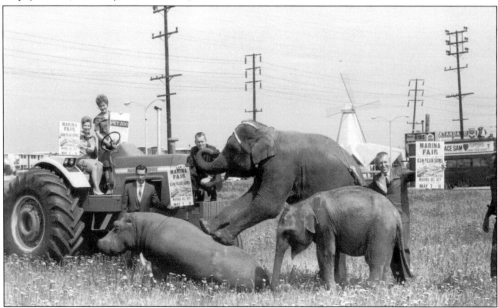

Another event intended to attract the public's attention to the location of the marina was a mini-zoo exhibit. It occupied the empty parcel between Admiralty Way and Lincoln Boulevard and between Bali Way and Mindanao Way. The windmill building in the background is the iconic symbol of the Van de Kamp's Bakeries, which stood on the east side of Lincoln Boulevard. (Courtesy of LACDBH.)

Four

Land Development, Fisherman's Village, Public Services

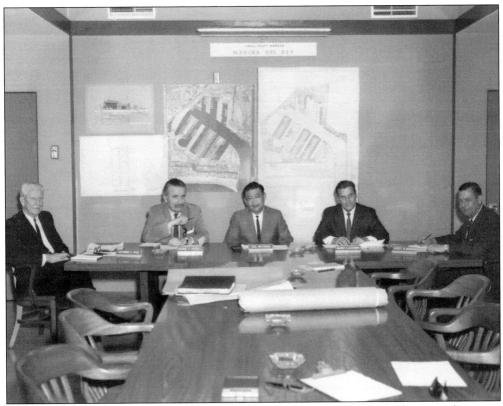

Marina del Rey development was controlled by the Design Control Board, whose members were appointed by each supervisorial district. The members in 1962 are, from left to right, Raymond E. Page, George V. Russell, Taul Watanabe, Maurice Fleishman, and Robert M. Murdock. Every project's architectural designs, signage, parking, and extra components were subject to review and approval. When passed, the project was also reviewed by county staff. Final approval was given by the county's board of supervisors. (Courtesy of LACDBH.)

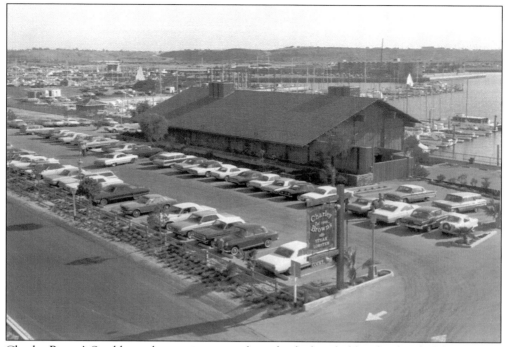

Charley Brown's Steakhouse lost no time in applying for the leasehold at the "head of the marina." Its site, on Admiralty Way, had a north-south view of the marina and no anchorage slips. Located close to the site of the former Mud Lake, the restaurant, seen here in 1965, became an immediate favorite of sailors and diners. Its current name is Tony P's Bar & Grill, a popular dining spot. (Courtesy of LACFD.)

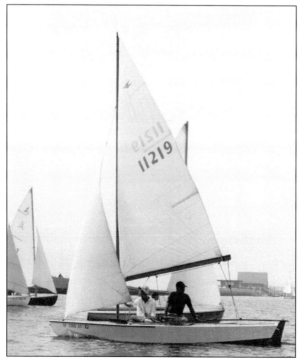

Sailing scenes, such as the one shown in this 1966 photograph of a Snipe sailboat and a Lido sailboat, were typical of the view from Charley Brown's restaurant. Boat slips were ultimately added for the adjacent Station 110 Fire Station. The California Yacht Club has several fingers of slips in front of the current Tony P's Bar & Grill. (Courtesy of LACFD.)

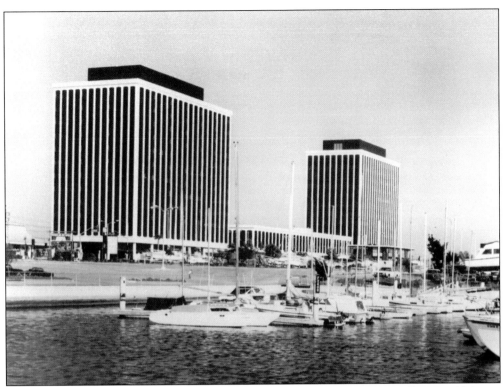

The TriZec Towers, built by a Canadian development company, were originally named Marina Airport Plaza. However, the name was often confused with other "airport" buildings that were actually closer to Los Angeles International Airport (LAX). North and South Admiralty Towers did not prove to be a popular name, either. The TriZec Towers are occupied by doctors, lawyers, a bank, the University of Southern California Sea Grant, and other professional tenants. (Courtesy of LACFD.)

A harbor cruise loads at the concrete dock in the Fisherman's Village area in 1966. *Little Toot*, a tugboat, was the perfect vessel to cruise the basins at about five knots. Passengers could view the various structures being built and just enjoy the fresh air and water experience. (Courtesy of LACDBH.)

In the early days of the marina, one fireboat existed. It could be run by an engineer, captain, and fireman. While docks and facilities were being built, the Harbor Patrol, with two boats, shared the docks with the fireboat and the lifeboats that were used by the Coast Guard. This photograph was taken in 1962. (Courtesy of LACDBH.)

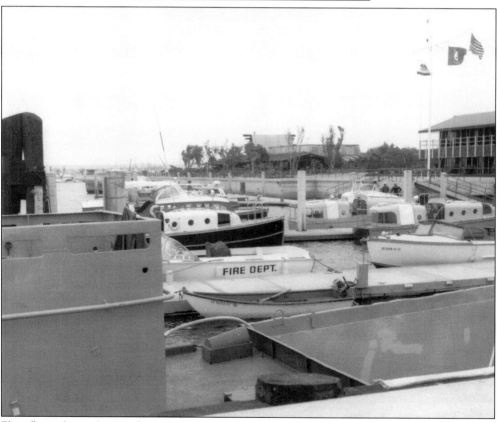

Flags fly on the yardarm in front of the Harbor Administration Center building, indicating that the facility has been commissioned. Pieces of Eight restaurant can be seen in the background of this 1963 photograph. The lifeboats used by the US Coast Guard were finally supplemented with the addition of the 82-foot cutter, which was readied for blue-water rescue. (Courtesy of LACDBH.)

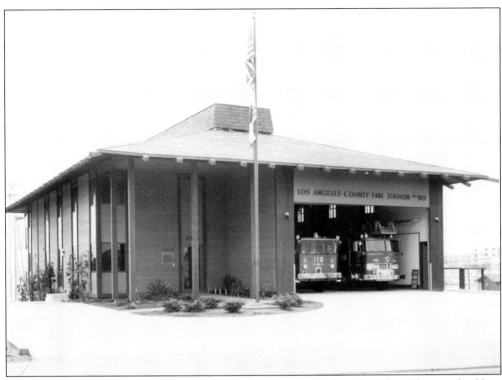

The original firehouse was in a trailer on the dirt bank of Admiralty Way. The new building (shown above) houses two fire trucks, including a hook and ladder truck and a paramedic full-response system. The more modern fireboat (below) can be seen at the fire station's own docks (left of center). Fire Station 110 Marina del Rey is situated at the head of the main channel, reducing the time it takes first responders to get to either side of the marina. The department also responds to apartment emergencies. (Both, courtesy of LACFD.)

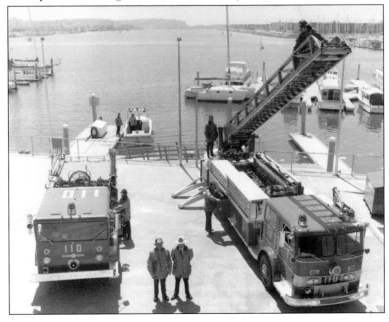

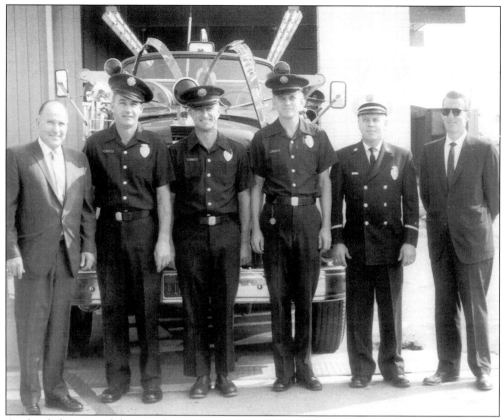

At the dedication of the new fire station, in November 1965, Aubrey Austin Jr. (far left) poses with three unidentified firemen assigned to the new station. Standing second from right is Capt. Mickey Foster, a legendary early firefighter in Los Angeles, then in Marina del Rey. At the far right is Arthur Will, director of the marina. (Courtesy of LACFD.)

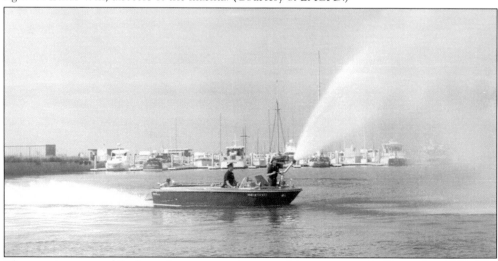

The new jet-powered fireboat demonstrates its powerful water spray in November 1965. The configuration of the boat's keel was intended to reduce wake when under way at more than five knots. Excessive wake can cause damage to docks and boats in slips. (Courtesy of LACFD.)

A 1965 open house at the new Marina del Rey fire station was an opportunity for the public to tour a fire station on the waterfront. This miniature fire truck demonstrates the new features on the real vehicles. (Courtesy of LACFD.)

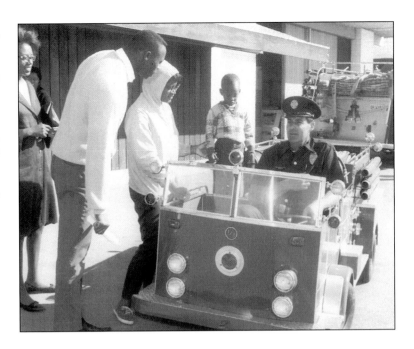

The rigid hose units on the side of the truck were used to increase the pressure of the water from the hydrants to the truck. The units could then pump the water on land to apartment fires or help squelch fire on a boat if the boat was towed to a vacant seawall near a hydrant. Marina del Rey was well prepared for such emergencies. This photograph was taken in 1970. (Courtesy of LACFD.)

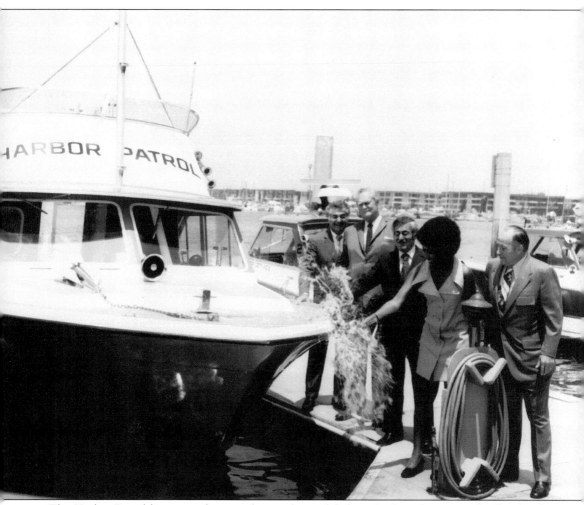

The Harbor Patrol boat was christened in traditional fashion by launching it with a bottle of champagne. Among those shown here are four unidentified harbor commissioners. The Harbor Patrol was composed of uniformed peace officers, who had limited law-enforcement authorization while on duty. Off duty, they were civilians. Most of the officers had been in the US Navy, and they brought boat-handling knowledge to the patrol. Leo Porter was the first Marina del Rey harbormaster. In April 1984, the Harbor Patrol was merged into the sheriff's department, making Marina del Rey a substation of the Lennox Division, Los Angeles County Sheriff's Department under Capt. Rob Lyons. Lt. Tom Sherrill was the harbormaster from 1984 to 1985. Sgt. Gary Thornton, a member of the original Harbor Patrol, served under four captains as harbormaster until he retired in 2005. In 1979, harbor patrolman Harold Edgington, one of the original peace officers, was killed by a deranged man near Panay Way. The 16-year officer was remembered by the community with the naming of Edgington Park, located at the corner of Via Marina and Admiralty Way. (Courtesy of LACDBH.)

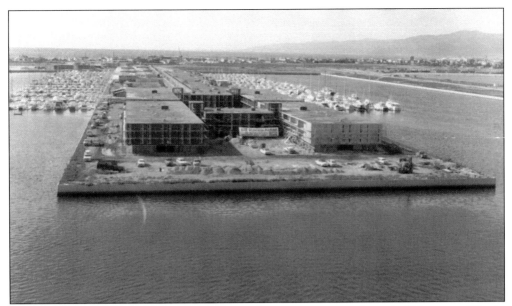

Deauville Apartments, Parcel 12, are shown under construction at the end of Marquesas Way in 1965. Boat slips at Villa del Mar Anchorage Basin C, on the mountain side of the mole, appear to be filled with vessels, as are the slips on the Basin B side at Neptune Marina. The anchorage portion of Deauville has no pilings or docks at the time of this photograph, but it will eventually have them. (Courtesy of LACFD.)

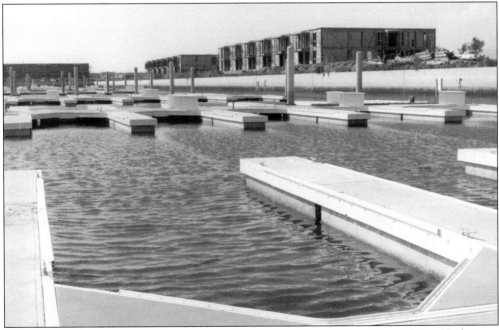

Boat slips are empty at this apartment development on Tahiti Way, Marina Point Harbor, on Basin A. The undeveloped area to the right is the site of the future Tahiti Marina Apartments. The docks at this facility were completed in 1964 after the sheet-pile baffles were installed in the main channel to protect against storm surge. Tahiti Yacht Landing was the original marina name. This photograph was taken in 1965. (Courtesy of LACFD.)

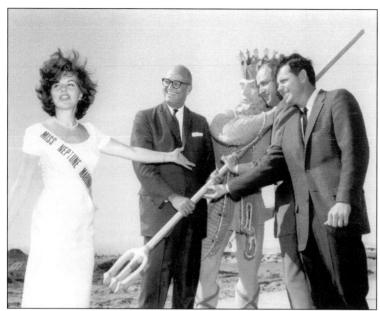

In 1965, Congressman James Roosevelt (center) joins King Neptune and Miss Neptune Marina in a groundbreaking ceremony for the Neptune Townhouses and Marina. On the right are Samuel Leeds and Jay Platt, part of the development company. Roosevelt was an important force in obtaining funding for marina projects. (Courtesy of LACFD.)

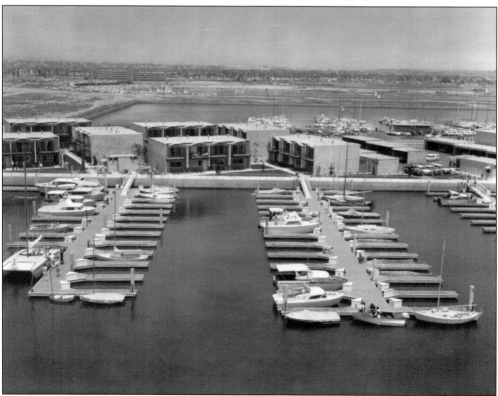

The Neptune Townhouses, seen here in 1965, were highly sought after in the early years. The after-work "swinging singles" crowd filled the waterfront restaurant, Donkins, later named Clems. The restaurant's guest dock for boats was constantly filled. The marina slips were the home to Wind 'N' Sea Sailing Club, a low-cost membership club that shared a variety of boats. Malcolm Steinlauf was the founder and commodore. (Courtesy of LACFD.)

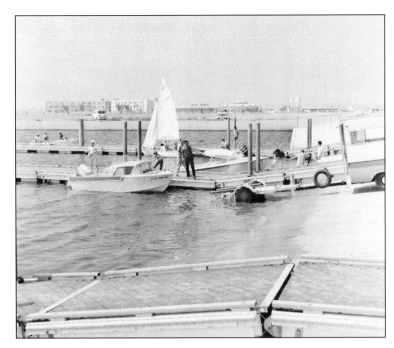

The public launch ramp, seen here in 1966, is accessible from either Mindanao Way or Fiji Way. The facility had three areas of wooden ramps off concrete and asphalt parking lots. It is a very popular site for activity, especially in the summer months. Fishermen take off shortly after dawn and return early in the afternoon. (Courtesy of LACDBH.)

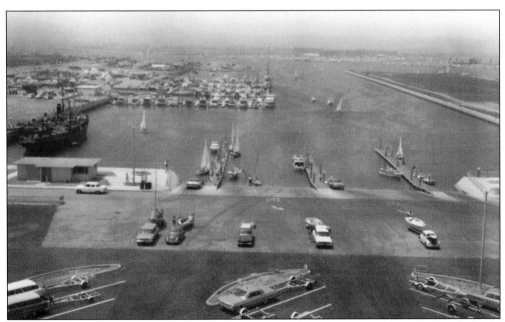

The launch ramp, seen here in 1966, opens onto a large basin area, which is called Dock 52. At the public parking area, large commercial fishing boats or cruise-charter boats can arrange to pick up groups for fishing expeditions, whale watching, or harbor cruises. The county operates the launch ramp facility and parking area, but charter operations are conducted by licensed private commercial vessels. (Courtesy of LACDBH.)

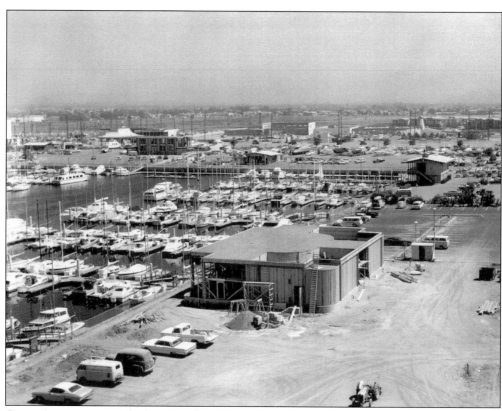

Cyrano's restaurant was built in 1967 by proprietor John Oldrate, a well-known Sunset Boulevard restaurateur. Celebrities enjoyed his cuisine and the elegant ambience of waterside dining. The restaurant's large guest boat dock appealed to dining boaters. As the clientele changed to younger crowds, the leasehold was transferred to new owners. The site was renamed Moose McGillycuddy's and then Waikiki Willie's. The facility, seen here in 1967, has since reverted to the county. (Courtesy of LACFD.)

Cyrano's was often the site of Marina Chamber of Commerce social mixers. Seen here in 1967, the restaurant's host, John Oldrate (third from left), is in conversation with Rudy Abeyta (second from right), owner of the Cleaning Baron, and Jim Coughlin, executive director of the Marina Chamber of Commerce. The two women are unidentified. (Courtesy of LACDBH.)

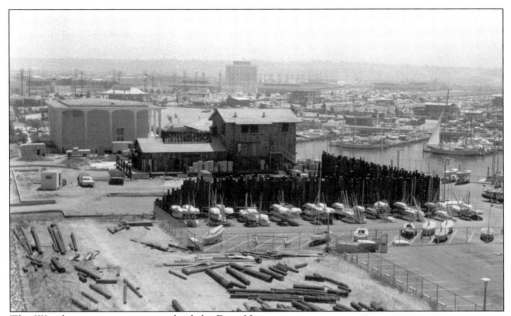

The Warehouse restaurant was built by Burt Hixson, an award-winning cameraman turned restaurateur. Designed in a tropical theme, the restaurant's "tin roof" and setting among palm trees, bamboo clusters, and weathered wharf posts were his signature. The posts were trucked in from San Pedro, along with old whiskey kegs, nautical rigging, nets, and hawser ropes. Hixson's photographs lined the walls. Exotic drinks, food, and a waterfront view made it an instant favorite. The Warehouse is seen here in 1969. (Courtesy of LACFD.)

Burt Hixson's straw hat and safari attire were his trademark. His early efforts to promote the new marina and its restaurant destinations through the Marina Chamber of Commerce and the Restaurant Association assisted in the economic success of Marina del Rey's early restaurants. (Courtesy of MDRHS.)

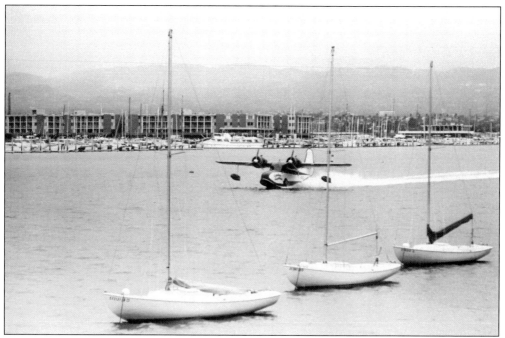

In 1969, service was easy and quick to Catalina Island, "26 miles across the sea" by seaplane. Catalina Seaplanes (1966–1972) operated a five-passenger "Grumman Goose," shown here taking off in the main channel past a moored fleet of Victory sailboats. The boats were available for rent at Rent-A-Sail at Fisherman's Village. (Courtesy of LACFD.)

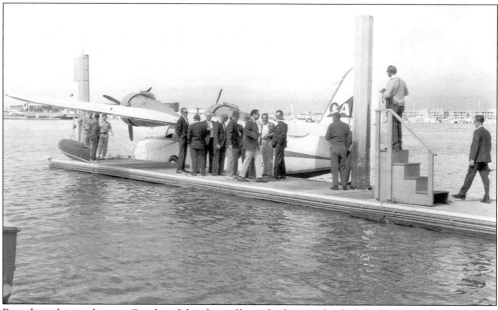

Boarding the airplane to Catalina Island usually took place at the fuel dock, as seen here in 1970. The flight took 20 to 30 minutes, depending on the area visitors were headed for. Boaters had to be sure to anchor away from the seaplane landing area at Catalina. Many new boaters did not know the landing area's location at Two Harbors Isthmus, which called for very hurried cries of "Move your boat now!" (Courtesy of LACFD.)

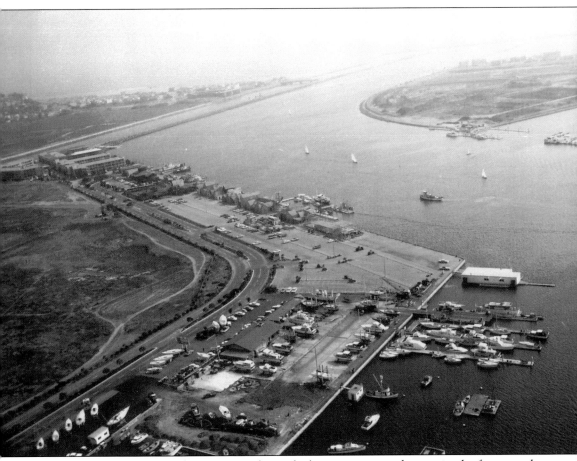

Development on Basin H, the commercial area for boat repair, is under way in the foreground of this c. 1969 photograph. The baffles are gone, and the breakwater can be seen faintly in the upper area of the photograph. The white, rectangular building with floating dock at the corner point of Basin H and the main channel is the new Loyola Marymount University boathouse, which houses rowing shells. The college rowing teams practice on the water at five o'clock in the morning. Fisherman's Village is being built along the waterway at center. Its lighthouse, under construction close to the docks, will become an iconic structure at Marina del Rey. At upper left, the white-roofed building between Villa Venetia Apartments and the south jetty is the present-day UCLA Marina Aquatic Center. This center and its launch ramp is the site of sailing classes, scheduled every day, including weekends. The undeveloped property across the main channel will become Mariners Village townhouses and apartments. The Union Oil fuel docks extend into Basin A from Bora Bora Way. (Courtesy of LACFD.)

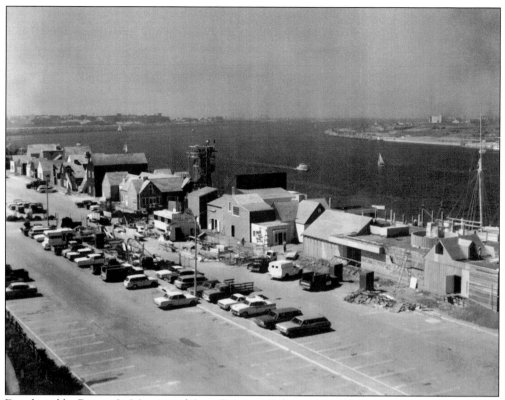

Developed by Bryant L. Morris and Stan Berman, Fisherman's Village nears completion in late 1969. Artist Raymond E. Wallace created renderings evoking a New England seaside, Cape Cod–style village. Architect Norv Pieper drew construction plans based on Wallace's drawings, and Sheldon Pollock Co. built the center. (Courtesy of LACDBH.)

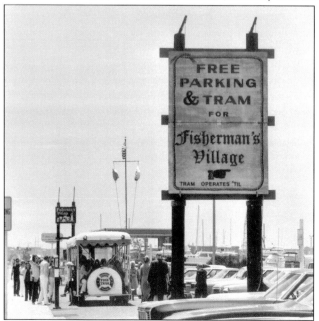

Visitors to Fisherman's Village, seen here in 1973, could park at the Dock 52 lot on Fiji Way, take a free tram to the center, enjoy shopping, dining, boating, or fishing, and return to their vehicles via the tram. The arcade was a popular place. Fishing aboard the *Betty O*, Captain Frenchy's trawler, provided many happy hours at sea for fishermen and fisherwomen. (Courtesy of LACDBH.)

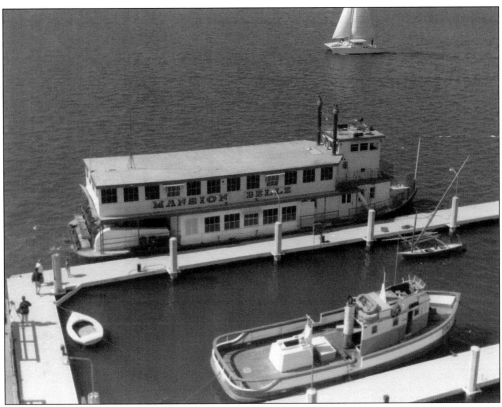

The *Mansion Belle*, a Mississippi River–style paddle-wheel boat, was a tourist's delight as it made its way around the calm waters of the harbor and the main channel within Marina del Rey's outer breakwater. A Malibu outrigger sailboat is at the dock, a catamaran is in the main channel, and the tour tugboat *Little Toot* is docked in the foreground of this 1970 photograph. (Courtesy of LACFD.)

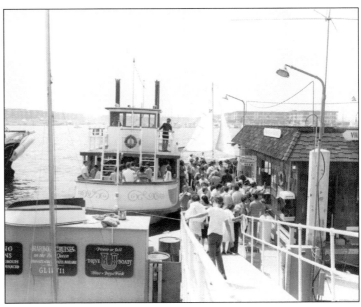

One of several harbor cruises departs from Fisherman's Village in 1970. Cruises operated as often as every 35 minutes on weekends. Scenic rides were a very popular activity for visitors, resulting in a waiting line for tickets. Each boat had a public-address system, allowing the captain to point out the sights, including celebrities' boats. (Courtesy of LACFD.)

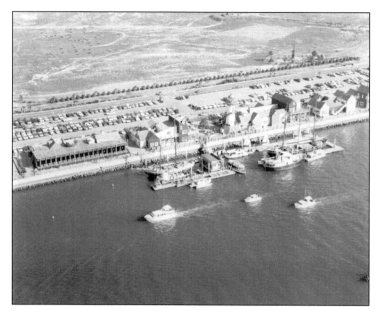

The southwest-facing view in this aerial photograph shows Fisherman's Village in 1973. Developers Morris and Berman owned and operated the center for three years, then sold it for $2 million to Real Property Management in August 1972. At the time of sale, the center was fully leased, with 38 specialty shops, three restaurants, and extensive boating and fishing activities. (Courtesy of LACDBH.)

Newly opened in 1969, Fisherman's Village offered a beauty salon, a wig shop, art galleries, and an array of clothing, gift, and craft retailers. Original restaurant tenants were El Torito, the Fish Market, Port D'Italy, Orange Julius, Hot Dog on a Stick, and Captain Saul's. (Courtesy of LACDBH.)

Had the outer stairwell been wide enough to pass construction code, the 60-foot-tall structure at Fisherman's Village might not have resembled the lighthouse familiar to all today. Instead, the stairwell's width remained narrow, public access was off-limits for decades, and the structure's iconic New England lighthouse image was preserved. (Courtesy of LACFD.)

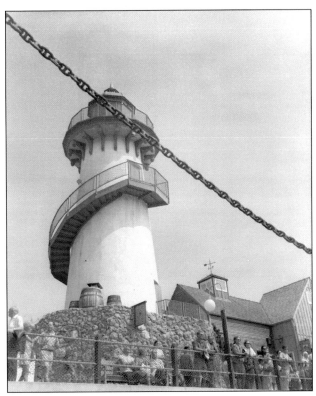

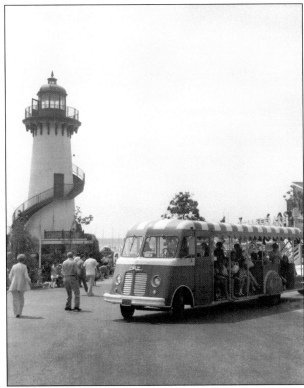

The open-air, colorful tram, seen here in 1970, ran continuously during the weekends. It was just one part of the experience of visiting Fisherman's Village. Visitors could take a harbor tour, go to the arcade, or have a hot dog and just wander about the pebbled waterfront walkway, watching the boats. (Courtesy of LACFD.)

The first boat repair yard was Windward Yacht Repair, seen here in 1969. Situated on Fiji Way by Basin H, it eventually had a 100-ton travel lift operation. It was operated by Jacob Wood, who owned a series of racing yachts, each named *Sorcery*. The first boats brought in for repair were lifted by crane and set on dollies, then on blocks in the area where they would be worked on. (Courtesy of LACFD.)

The second repair yard was the Chris-Craft Boat Repair yard, operated by George Agajanian. Seen here in 1969, the yard catered to smaller boats and used a crane for lifting craft out of the water onto dollies. The county required this boatyard to establish a do-it-yourself facility after boat owners in the 1970s demanded a facility where they could work on their own craft. (Courtesy of LACFD.)

The first bank building, Civic National Bank, was designed by Guy A. Bartoli for leaseholder Lloyd W. Taber. The bank, seen here in 1970, was on Admiralty Way, next to the Warehouse restaurant. Bartoli designed a large percentage of the single-family homes on the marina peninsula following the stabilization of the real estate market with the success of the breakwater as a storm surge deterrent. (Courtesy of LACFD.)

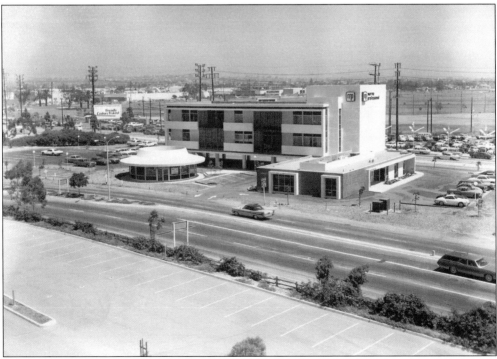

The first medical building was erected on the land strip between Lincoln Boulevard, Bali Way, and Admiralty Way, just north of the TriZec Towers. Before this property was developed, it was the site of fairs and amusement-park events. The University of California, Los Angeles (UCLA) has medical outpatient offices and a clinic here. In addition, a pharmacy serves the community. This photograph was taken in the 1970s. (Courtesy of LACFD.)

Marina del Rey's shopping center, seen here in 1968, featured a Boys Market, a laundry with washing machines, a hair salon, a few specialty and clothing stores, a movie theater, a drugstore, and Security Pacific National Bank. There was always sufficient parking. Mr. D's restaurant was a popular and reasonably priced diner. Boys Market prepared gourmet baskets for boat owners headed out for a day on the water. (Courtesy of LACFD.)

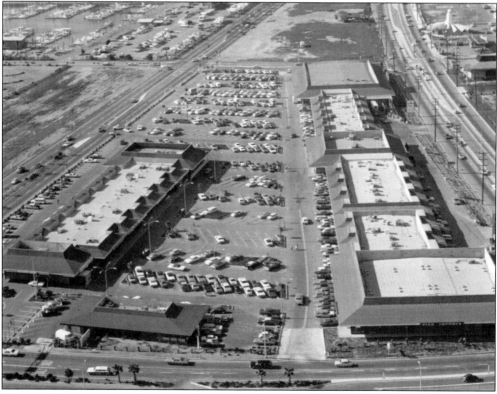

The north-facing view in this aerial photograph shows the Marina del Rey Shopping Center in 1968. The main channel is beyond the photograph, to the left. The center, now called Waterside at Marina del Rey, has been upgraded and refurbished by successful developer Rick Caruso. Mr. D's is now California Pizza Kitchen, Boys Market is now Ralphs Market, and Bank of America has acquired Security Pacific. Upscale fast-food cafés and clothing boutiques now abound. (Courtesy of LACFD.)

The footprint of the huge complex named Marina City Club is evident in this 1970 photograph. There will be three residential towers, each 16 stories high, equipped with a fitness center, tennis club, bar/restaurant, spa, on-site beauty services, store, and more. There will be 600 residential units, condominiums, apartments, and boat slips. (Courtesy of Greg Wenger Photography.)

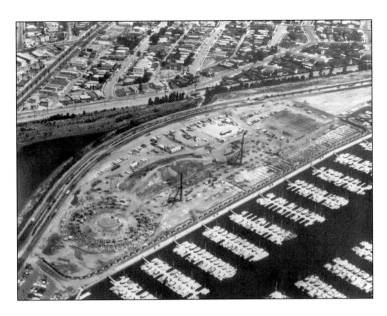

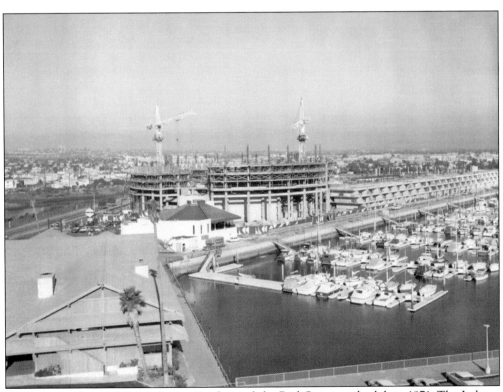

The Marina City Club West Tower rises beyond the Red Onion nightclub in 1971. The Lobster House restaurant is in the left foreground. The three-tower project will take six years to complete and will be Marina del Rey's only high-rise at water's edge until the Ritz-Carlton hotel is built years later. The promenade apartments are at center right, appearing as small white squares. (Courtesy of Greg Wenger Photography.)

An unidentified sheriff's department officer (far left) is being recognized at a Marina del Rey ceremony. Shown with him are, from left to right, Jerry Epstein, developer, in 1965, of Del Rey Shores; Leo Porter, harbormaster of Marina del Rey; Robert Leslie, executive director of the Marina del Rey Lessees' Association; Sheriff Peter Pitchess of the Los Angeles County Sheriff's Department; Victor Adorian, director of Marina del Rey; an unidentified sheriff's department officer (partially obscured); Leo Bialis, harbor lease and finance administrator; and Jim Quinn, of harbor development and operations. The happy occasion is reflected in the participants' smiling faces. The Marina del Rey Lessees' Association was composed of parcel leaseholders who invested money in their respective developments. The sheriff's helicopter dates this photograph to the 1960s or 1970s. (Courtesy of LACDBH.)

The public celebrates opening day for the US Coast Guard station, the Harbor Administration Center, the Harbor Patrol office, and the county staff offices in 1963. The 82-foot cutter (left) sits alongside the Coast Guard dock. At right are a Harbor Patrol boat and a lifeguard boat, but only pilings, as there are no permanent docks yet. The Coast Guard helicopter displays its landing and rescue abilities for the large crowd. (Courtesy of LACDBH.)

The *Point Bridge*, a Coast Guard cutter, is a state-of-the-art power vessel with a pair of 800-horsepower diesel engines. The 82-foot vessel cruises at 17 knots and has an operational range of 1,000 miles. Designed to allow 360-degree visibility from the bridge, the cutter, shown here in 1963, also has night-lights, air-conditioned quarters for a crew of eight, and a galley with freezer and refrigerator. Its home base was Marina del Rey. (Courtesy of LACDBH.)

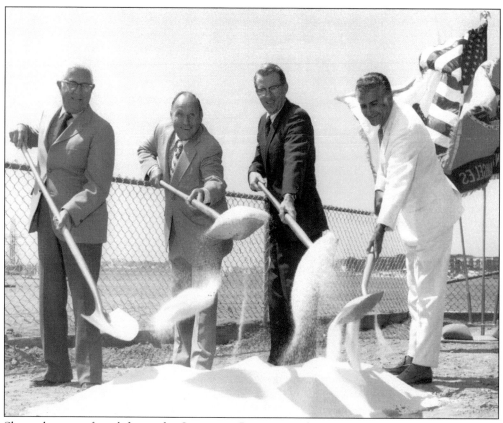

Shown here are, from left to right, Supervisor Burton W. Chace, Aubrey Austin Jr., Arthur Will, and Victor Adorian. They are marking the start of construction of Burton Chace Park with a ceremonial ground breaking on August 22, 1972. The park, at 13650 Mindanao Way, is named in honor of Chace, "Father of the Marina," who worked diligently with county staff to bring Marina del Rey to reality. (Courtesy of LACDBH.)

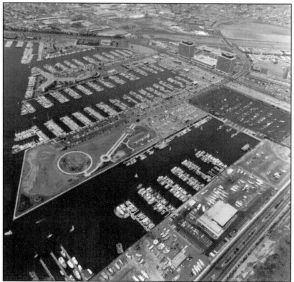

The white parallel walkways in the center of this aerial photograph, taken in 1972, lead to what will be the community room, in the area of the white circle. The grassy mounds will be open areas for play, concerts, and special events. There will also be picnic areas with built-in barbecues, a special fishing dock, and great harbor viewing areas. (Courtesy of LACFD.)

Attired in foul-weather gear and ready for his eventual watch at harbor's edge, *The Helmsman* bravely weathered his journey through early-1970s Los Angeles traffic to the new Burton W. Chace county park. Seen here in 1972, the statue is well received by both children and gulls at its new location. (Courtesy of Greg Wenger Photography.)

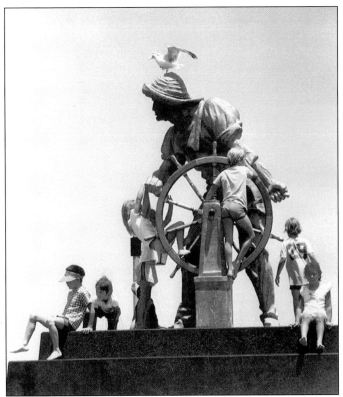

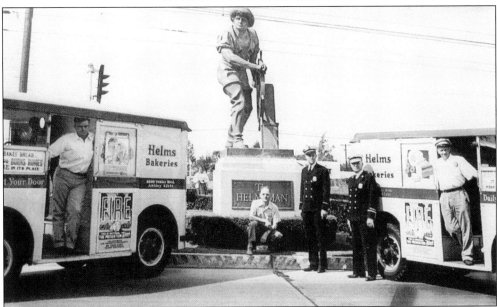

Originally located on Venice Boulevard at Helms Bakery in Culver City, the statue was donated to the marina through the efforts of Dr. Earl Bubar, president of Venice Chamber of Commerce. The Helms trucks in this c. 1954 photograph carry a fire-prevention message. An illustrated image of *The Helmsman* would for decades adorn the masthead of Marina del Rey's local newspaper, the *Argonaut*. (Courtesy of LACDRP.)

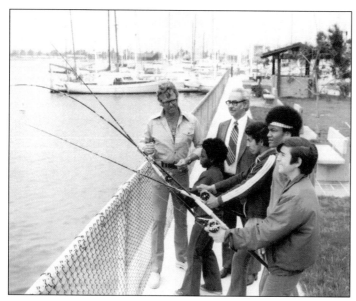

The Burton Chace Park fishing dock was a popular location for anglers both young and old. The park also has a fish-cleaning and prep facility. In this 1972 photograph, youngsters from the Boys Club of Venice are being taught fishing tips by unidentified volunteer mentors. David Mandell (not pictured) founded the Boys and Girls Club of Venice, whose current activities include sailing and kayaking. (Courtesy of Greg Wenger Photography.)

Architect Suat Kepenek's simple nautical theme graces Burton Chace Park, as seen in this 1972 photograph. Posts and beams are designed into romantic bridges, arboreal structures, and landscaped walkways offering picturesque views of the Marina del Rey harbor. All posts were pressure-treated and colored dark brown to make them stand out against the harbor's white sails and the green lawns of the park. (Courtesy of Greg Wenger Photography.)

This 70-foot lighted observation tower, located on a mound near the water's edge at Burton Chace Park, was intended to serve as a navigational landmark for skippers returning to port. It was a popular lookout platform for spectators to view the boats traversing the marina. This photograph was taken in 1972. (Courtesy of Greg Wenger Photography.)

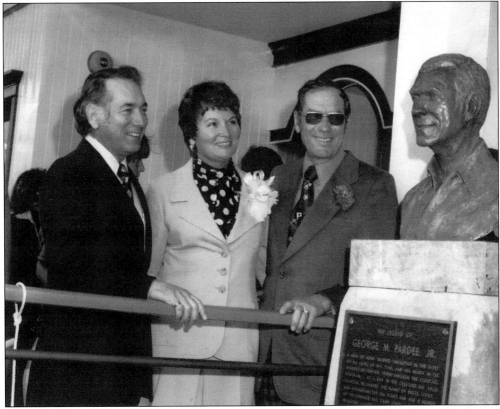

The Pardee Scout Base, located at the Burton Chace Park, was generously endowed by George M. and Katherine M. Pardee, pictured here with Fourth District supervisor James Hayes (left). A replica of a large river tugboat became the clubhouse for the Sea Scouts division of the Boy Scouts of America. The docks attached to the facility accommodate donations of boats to the Sea Scouts and are used in boat handling and safety. (Courtesy of LACDBH.)

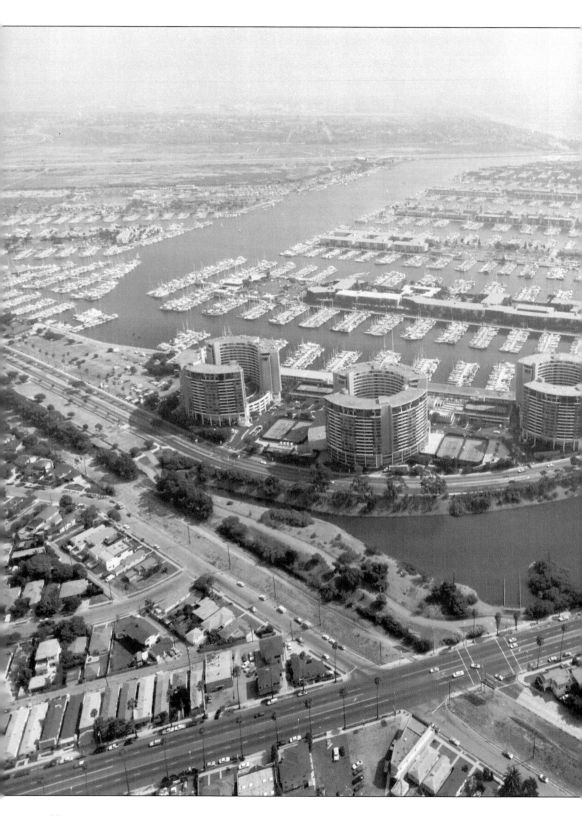

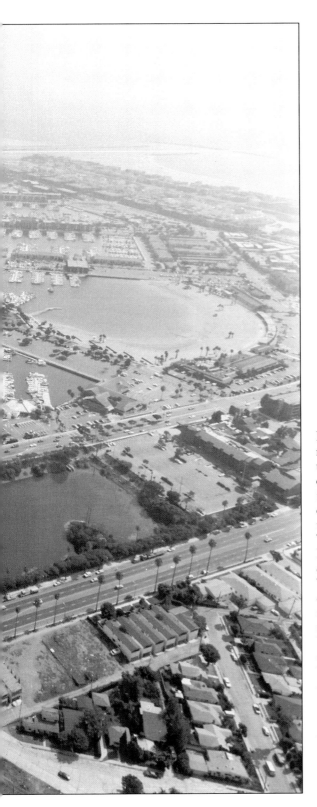

Development of Marina del Rey is nearing completion in this photograph, taken around 1979. The last major construction of the Marina City Club is complete. The vacant lot to the left of the three towers is the future site of the Ritz-Carlton Marina del Rey Hotel. The lake in the foreground is the Oxford Flood Control Basin, constructed to control and contain seasonal rain runoff. Traffic moves around the perimeter of the marina on a four-lane divided roadway. Boat slips are at a premium and in short supply. The popularity of boating reflects the presence of many aerospace and technology professionals buying the affordable fiberglass boats of the era. Burton Chace announced in a press release on June 19, 1972, that Marina del Rey was meeting its financial goals "since Marina finances entered the black in 1967" and was accelerating retirement of the state loan, made in 1958, to build the marina. (Courtesy of Greg Wenger Photography.)

In 1972, the first payment of $325,000 of the $2 million land acquisition loan from the California State Navigation and Ocean Development (CSNOD) for Marina del Rey was presented to CSNOD commissioner William DeGroot (second from right) by Supervisor Burton W. Chace (center). Aubrey Austin Jr., Small Craft Harbor Commission chairman, is at far left. Arthur Will, county chief administrative officer who guided the marina from 1963 to 1971, is standing second from left. At far right is CSNOD commissioner Bill Satow. (Courtesy of LACDBH.)

Called an "ecological aid" to coping with waterborne debris, the county's 17-foot debris-collector boat is shown here being operated by Mathew Miles, senior general maintenance, Department of Small Craft Harbors. The craft collected trash floating in from Ballona Creek and from two storm drain outfalls that emptied into the Marina del Rey basins. The marina in 1970 was home port to over 5,000 boats. This photograph was taken around 1970. (Courtesy of LACDBH.)

Five
BOATING, RECREATION, YACHT CLUBS

With sails "full and by" in Marina del Rey in 1971, it was time to bring out the Amphicar. This vehicle was built in Germany from 1961 to 1968. Optional undercoating was highly recommended. Fitted with a Triumph engine, it could do seven knots in the water and 70 miles per hour on land. It required two registrations, one for a California boat registration number (CF) for water usage, and the normal vehicle license for the highway. (Courtesy of Greg Wenger Photography.)

At the 1971 annual meeting of the Pioneer Skippers Boat Owners Association (PSBOA), president Doug Nash (standing) introduces the panelists, including personnel from the county harbor administration. Shown here are, from left to right, John T. Hjorth Jr., vice president, PSBOA; Leo Bialis, harbor lease and finance administrator; Victor Adorian, director of Marina del Rey; Nash; Capt. William Finnegan, Harbor Patrol; Richard Landon, county public information officer; and Jim Quinn, harbor development and operations. Spirited discussions took place on issues concerning dock maintenance, slip fees, live-aboard policies, and rental agreements. A mediation committee of county officials, boat owners, and lessees was established to hear grievances brought on by issues stemming from near-full occupancy of the boat slips. The do-it-yourself boat repair yard was also established. The founder of PSBOA, in 1963, was John Thomen (1909–1968), who was also a member of the Marina del Rey Coast Guard Auxiliary, Flotilla No. 52. (Courtesy of Greg Wenger Photography.)

In the photograph below, PSBOA president John T. Hjorth Jr. commemorates the appearance of Los Angeles County Fourth District supervisor Yvonne Braithwaite Burke as grand marshal of the Pioneer Skippers 1979 Christmas Boat Parade. Burke, then a resident of Marina del Rey, was appointed to succeed Supervisor James Hayes, who resigned. Hayes had succeeded Burton W. Chace in 1972, after a freeway accident claimed Chace's life. Deane Dana was elected in 1980, followed by Don Knabe in 1996. Burke served as supervisor of the Second District of the County of Los Angeles from 1992 to 2008. At right, the holiday-decorated sailboat bearing the message "Christmas Morning" was a crowd-pleaser and sweepstakes winner in an early Pioneer Skippers Christmas Boat Parade. (Both, courtesy of Greg Wenger Photography.)

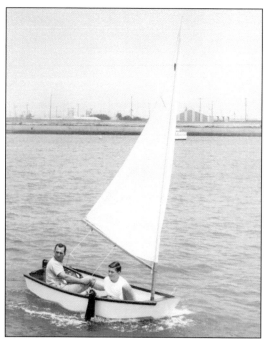

A Southern California eight-foot sailing pram, the *Naples Sabot*, sports a sleeved mainsail and a side leeboard instead of centerboard. The craft stayed dry without water coming up through a centerboard hole. It could be towed behind a boat without swamping (filling with water), and it could serve as a rowboat or shore boat. Seen here around 1966, the *Naples Sabot* became a teaching staple to juniors and adults learning to sail in Marina del Rey. (Courtesy of LACDBH.)

These Marina del Rey yacht racers are rounding a mark of the course around 1966. The three sailboats, of distinct designs, compete against each other by means of a handicapping system to equalize their sailing characteristics. Shown here are a 26-foot Thunderbird with fractional sails rig (left); a Columbia 24-foot-long sloop-rigged (center); and a two-masted Herreshoff 28, a classic East Coast cruising ketch-rigged wooden boat built by renowned designer L. Francis Herreshoff. (Courtesy of LACDBH.)

California Yacht Club's storied history of trophies in rowing, power, and sail competition dates to 1922. CYC members have won medals at the 1932 and 1984 Olympic Games in Los Angeles. The club moved to the Marina del Rey Sheraton Hotel in 1963. This photograph shows the club's 1966 dedication of its present-day clubhouse on the triangular parcel at the north end of the main channel. (Courtesy of LACDBH.)

The prestigious California Cup was deeded to the California Yacht Club by members in 1963. Seen here in 1967, yachtsman Robert Lynch (left), California Yacht Club 1967 commodore William DeGroot (center), and Arthur Will, director of Marina del Rey, review past winners' plaques. The 1968 winner was CYC's owner, Charles Hathaway, whose Columbia 50, *Gem*, took top honors. (Courtesy of LACDBH.)

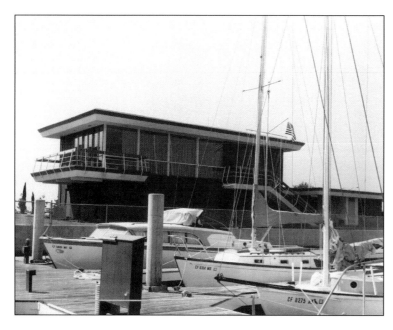

Pacific Mariners Yacht Club's (PMYC) present-day facility is at 13915 Panay Way, where it has resided since 1968. The club and its 125 members moved from its temporary clubhouse in 1966. PMYC, which describes itself as a do-it-yourself club, is operated by the members themselves, with no paid staff. The clubhouse is seen here in 1967. (Courtesy of LACDBH.)

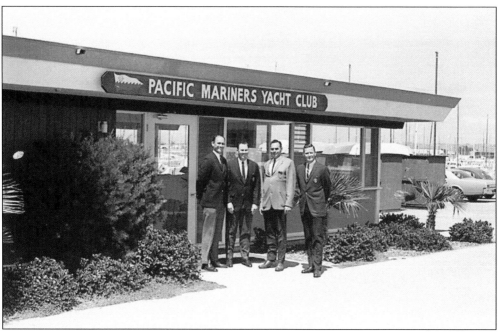

Pacific Mariners Yacht Club was founded in 1963 by local sailors interested in blue-water cruising and racing. Posing in front of the first clubhouse in 1967 are, from left to right, 1968 commodore David Free, 1963–1964 founding commodore Phil Murray, 1967 commodore Robert Woodworth, and 1966 commodore Gordon Teuber. (Courtesy of LACDBH.)

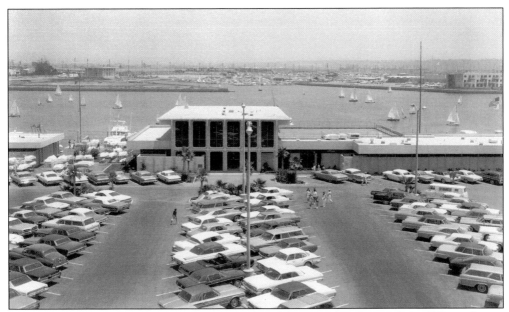

The five founding members of the Del Rey Yacht Club in April 1952 were Louis J. Rosenkranz, Charles E. Leveson, John R. Sahanow, Joseph Weiss, and William C. Stein. Del Rey Yacht Club signed its 60-year lease with Los Angeles County for Parcel 30 at the water end of Palawan Way in 1962. The clubhouse is seen here around 1967. (Courtesy of LACDBH.)

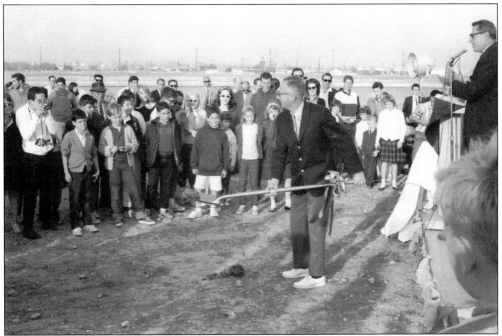

Commodore Lou Rosenkranz breaks ground for the construction of the Del Rey Yacht Club clubhouse. It was dedicated in 1965. In October 1972, a second facility was established on Catalina Island at "Cat Harbor," on the west side of Two Harbors Isthmus. Del Rey Yacht Club's sponsorship of major international races is well known in yachting circles. (Courtesy of LACDBH.)

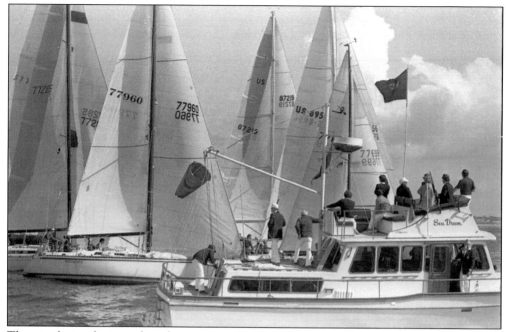

There is plenty of action when the gun goes off at the starting line, as boats maneuver for position to win big trophies, not to mention bragging rights! *Sea Drum*, a 42-foot trawler, is the perfect yacht to accommodate the knowledgeable race committee. From the yacht (foreground), officials will raise and lower the signal flags directing each class and will record the results. This photograph was taken around 1975. (Courtesy of Greg Wenger Photography.)

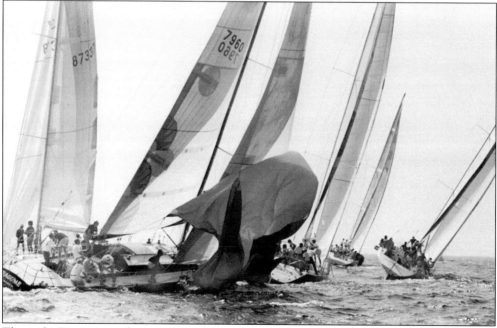

The yacht *Ragtime* rounds a course mark and douses its huge spinnaker while turning to head to the weather (upwind) course mark. All of the sailboats in this race appear to be competitively close to each other. (Courtesy of Greg Wenger Photography.)

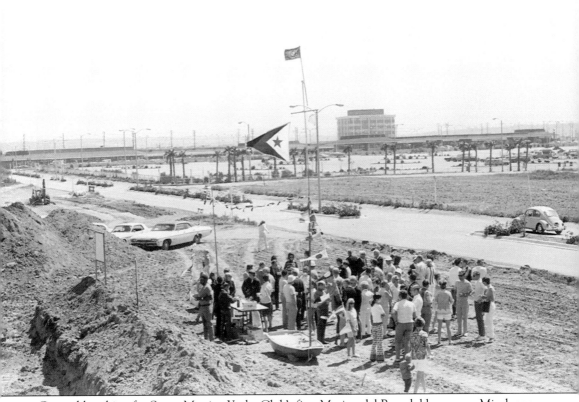

Ground breaking for Santa Monica Yacht Club's first Marina del Rey clubhouse, on Mindanao Way, took place in April 1969. Until the early 1930s, members sailed on Santa Monica Bay in a variety of boats, from dinghies to Malibu outriggers. The first club was the Santa Monica Sailing Club, which continued until 1938, when it merged with the South Coast Corinthian Yacht Club, started earlier in 1932 by Eugene Overton. A group of members wanting to do large-boat cruising organized the Santa Monica Yacht Club (SMYC) in 1941. When harsh storms destroyed the breakwater at Santa Monica Harbor, members eagerly advanced the planning of Marina del Rey. SMYC committees worked with Rex Thomson of the County Small Craft Harbors. As a result, SMYC was invited to be the only yacht club participant in the 1962 opening of the marina, which included yacht races, a luau, and a barbecue. SMYC held weekly "Haggerty Sea Shell races at Lake Venice" in the early 1950s. The lake is also known as Mud Lake and Lake Los Angeles. (Courtesy of LACDBH.)

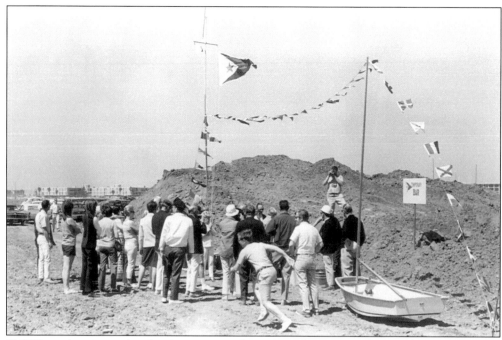

SMYC members jumped at the chance to purchase an anchorage site closer to the main channel. With expectations that membership would grow with the popularity of the new marina, SMYC purchased the Baja Marina in 1985. Pictured above, a new ground breaking takes place, with the clubhouse completed in 1986. Windjammers' Yacht Club (WYC), founded in 1961, held its activities at a clubhouse on Bali Way. The WYC facility was dedicated in 1967. Sailing had peaked with the demographic shift in the 1990s, and in 1999, WYC merged with SMYC, forming a single club, Santa Monica Windjammers' Yacht Club (SMWYC). The present-day clubhouse is located next to Burton Chace Park. The start of the 1977 WYC San Diego Race is shown below. (Above, courtesy of LACDBH; below, courtesy of MDRHS.)

The Classic Yacht Association has been a major influence in the appreciation of pleasure craft built mostly in the 1920s and 1930s. The power-driven boats range in size from 16 to 96 feet. The association has an annual Old Fashioned Day in the Park, which also features classic automobiles. Burton Chace Park is an ideal venue for the summer event, as seen here in 1977. (Courtesy of Greg Wenger Photography.)

These classic yachts participating in a 1977 parade circle the marina, passing Fisherman's Village before docking at Burton Chace Park. Many yachts come from Long Beach, where the Classic Yacht Association was organized to promote the preservation, restoration, and maintenance of old power-driven pleasure craft. The following three pages feature wooden sailing vessels of the Wooden Hull Owners Association (WHOA). (Courtesy of Greg Wenger Photography.)

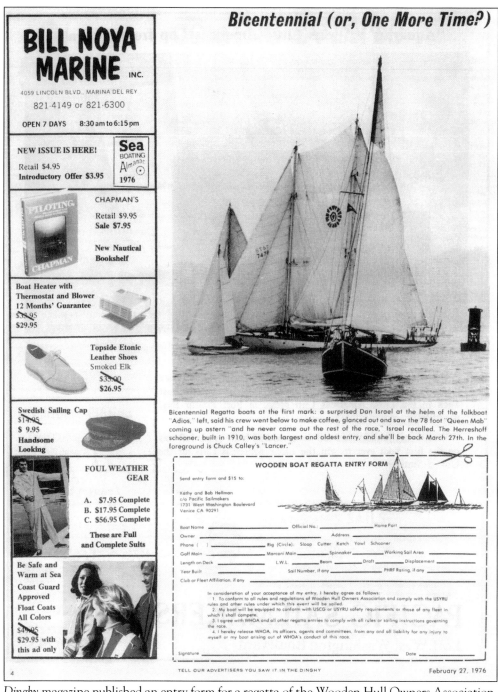

Dinghy magazine published an entry form for a regatta of the Wooden Hull Owners Association. Originally called the Bicentennial Regatta of the classic "iron men with wooden ships," when the starting gun went off on February 7, 1976, the 75 wooden boats were rained on, fogged in, and becalmed, and the regatta was postponed. Seen in the advertisement, Bill Noya Marine provided daily, nearly 10-hour access for boat owners' convenience. (Courtesy of MDRHS.)

Wooden Sailboat Regatta

Seventy-five wooden boats that were rained on, fogged in and becalmed during the Bicentennial Regatta February 7th, will return to the race start line Saturday, March 27th, to sail the Bicentennial (One More Time?) Wooden Sailboat Regatta.

And next time, the T-shirt manufacturer promises that the maroon bindings on the white shirts won't run off onto everyones' necks and arms.

Saturday, February 7th was a bleak day for hundreds of wooden boat sailors and the Classic Yacht Association wooden powerboaters who turned up for the first wooden boat regatta ever to be sailed at Marina del Rey.

"Galilee," Tom Carney's 44' gaff yawl, was lost en route to the regatta. Mistaking the mouth of the San Gabriel River for the Los Alamitos entrance channel, Carney was unable to fight a surge that put his boat on the beach, where waves pounded her to pieces.

"Wispy," Edward LeSage's 22' sloop from King Harbor, barely was tied to the dock at Burton Chace Park when a bigger boat brushed her, knocking off her mast.

From San Diego and Santa Barbara and all the ports between, wooden boats slipped into MdR Friday evening in the
Continued on next page

Could anything else go wrong? Kathy Hellman (left), regatta planner and coordinator, stares bleakly at the fog shrouded, becalmed wooden boat fleet during February 7th rainstorm. Bob Hellman's at the tiller of "Anna," crew Harold Pruett is on the right.

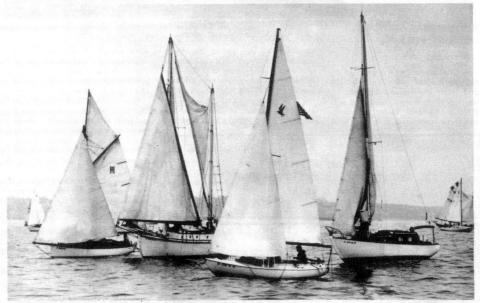

Sailing in two knots and a downpour: (from the left) "Stormcloud," "Vaya," "Bird" and "Stardust"

Greg Wenger Photos

When the Bicentennial Regatta was restarted on March 27, 1976, organizer Kathleen Hellman told of "praying to Odin, the wind god, for good winds." The 104 entries experienced gear-busting winds of 25–30 knots, with gusts up to 40 knots. The regatta became the "One More Time" regatta, with only 31 finishers. The racers took one look at the white caps on the water outside the breakwater, and most returned to their slips. The regatta remains an annual event, although wooden boats are becoming scarce. (Courtesy of MDRHS.)

A few hundred feet from the start line two hours after the regatta began: (from the left) "Don Quixote," "Windcall" and "Reliance"

BICENTENNIAL WOODEN SAILBOAT REGATTA

Continued from previous page

rain, reporting good wind outside. As the skippers huddled under cover for the grey, rainy skippers meeting Saturday morning, there was one moment of wild joy: Dave Agondo, harbor patrolman, turned up to announce that small craft advisories had been posted. The cheers and hurrahs were deafening and hundreds of sailors in three layers of clothes plus foul weather gear rushed out to the start line, only to find they'd been betrayed by the Wind Gods: one boat got across the line within seconds of the gun, a few staggered across nearly a half hour later, some managed it two hours afterward, and the last boat was towed across the line by frustrated crewmen who jumped overboard with bowlines after two hours of bobbing in the swells.

More than half the fleet made it to the first mark, the Santa Monica bell buoy, and about a dozen managed to round the second mark offshore, but only "Eclipse," Curtis Woods' PC, finished the race — then was protested for failing to round one fog-shrouded mark, and the protest was upheld.

"One more time?" Kathy Hellman, race coordinator, suggested at the non-awards ceremonies following the event, and all the wet, bedraggled sailors whooped with glee.

So with whatever reinforcements are mustered by March 27th, the Bicentennial Regatta, Part Two, begins again at 1300 about a mile off the MdR breakwater.

New T-shirts will be issued to all skippers and crew and the runny, ruined ones should be dropped off at Pacific Sailmakers, 1731 West Washington Blvd., Kathy Hellman has announced.

More information: 823-7245 days.

IF YOU ARE NOT HAPPY WITH TAXICAB SERVICE IN THIS AREA CALL 451-8757

Sextants — Chronometers — Ship's Clocks — Barometers — Logs — Electronic Instruments — Auto Pilots & Wind Vane Steerers — Hand Bearing Compasses.

Chris Bock INSTRUMENTS

4078 Lincoln Blvd., MdR 821-5811

TELL OUR ADVERTISERS YOU SAW IT IN THE DINGHY

February 27, 1976

Drifting around under the cover, waiting for the good wind, sailors burst into deafening roars as Dave Agondo, harbor patrolman, announced that small-craft advisories were posted. When the winds came in on March 27, most boats were overjoyed, as big wind is required to make the heavy wooden boats really sail. Too much wind took its toll, with sails shredded and sail track and shrouds being torn off. (Courtesy of MDRHS.)

South Coast Corinthian Yacht Club (SCCYC) was founded in 1932. In the mid-1930s, the club moored its fleet behind Santa Monica Pier's newly completed breakwater. Within a few years, deferred maintenance and storms accelerated the harbor breakwater's demise. SCCYC members promoted the development of Marina del Rey, and in 1966, the club moved into its clubhouse on Mindanao Way. In the photograph to the right, the clubhouse is behind the large white powerboat belonging to a SCCYC member. The 24-hour marathon race was conducted in eight-foot Sidney Sabots. Participants were from all yacht clubs. Some regattas served as fundraisers for children's charities. Laps raced were counted toward a total dollar amount. (Both, courtesy of MDRHS.)

The following caption was printed in *Dinghy* magazine in May 1977: "The 'Prince Louis' which sank suddenly May 6th at her moorings, was brought up nearly two weeks later by a group of owner Gene Klockovitch's friends who formed the Mad Dog Salvage Company and volunteered for the job. When she was up, one of the divers squirted air from his tank into the engine and the engine kicked over immediately – off they went to Commercial Boat Works in San Pedro (formerly Harbor Boat Works), where the three-masted cargo schooner from Europe was hauled. Last week the 'Perseus' joined the 'Prince Louis' in the haulout yard; 'Perseus' will return to Marina del Rey but 'Prince Louis' probably will not, according to Real Property Management (RPM) who own the 'Perseus' and the docks where both ships have been tied up for several years." (Courtesy of Greg Wenger Photography.)

Wind 'N' Sea Sailing Club members did not have to own their own boats in order to join. Members could share the fun with boat owners who needed crew to help on a day sail, to enter a Sunset Series Wednesday after-work race, or just to go "for a day sail" with sun and fun. For the Christmas Boat Parade, later renamed the Holiday Boat Parade, Wind 'N' Sea members were very creative with their colorful, festive displays, winning many trophies. In the summer, Wind 'N' Sea Sailing Club members entered doo-dah-style, on-the-water parades, with *Ladies Erotica Society* and *Godzilla* boat entries, as seen here in the 1970s. (Courtesy of Greg Wenger Photography.)

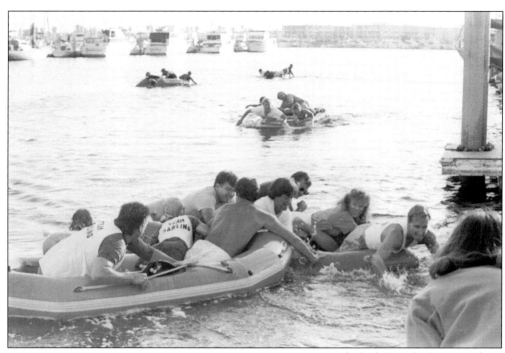

A "Hands Only Dinghy Race" took place frequently in the early 1970s at the California Yacht Club, in the Basin F area. Team Darling, led by Erma Darling and son David Darling, were the usual winners in the inflatable life rafts that raced from Commodore Howard Ryan's boat, *Windborne*, to the club's dinghy dock and back, about 250 feet. (Courtesy of Greg Wenger Photography.)

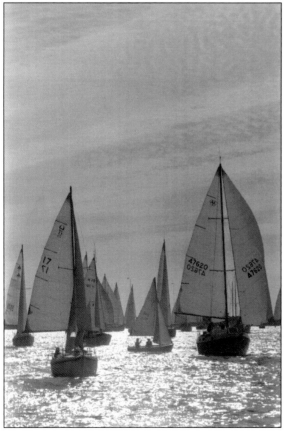

As women became more involved in cruising and serious sailboat racing, the need to improve boat-handling skills emerged. Lightweight boats in the 1970s, such as the Olson 30, demanded lighter, more agile foredeck crew to deploy spinnakers and perform sail tasks as vessels rounded race buoys. Several women skippered their own boats. The Women's Sailing Association of Santa Monica Bay (WSA) was organized in 1985. The club admits gentlemen. (Courtesy of Greg Wenger Photography.)

Six
VISIONARIES, CELEBRITIES, COMMUNITY

Posing here in 1962 is the staff of the Los Angeles County Department of Small Craft Harbors. They are, from left to right, (first row) Arthur Will, chief administrative officer; Victor Adorian, Marina del Rey director; and Jim Quinn, facilities planner; (second row) Capt. William Finnegan, Harbor Patrol; Leo Porter, harbormaster; Leo Bialis, harbor leases and finance; Richard Landon, public information officer; Merle Wilson, planner; Leonard Shortland, planner; and George Smith, county planning engineer. (Courtesy of LACDBH.)

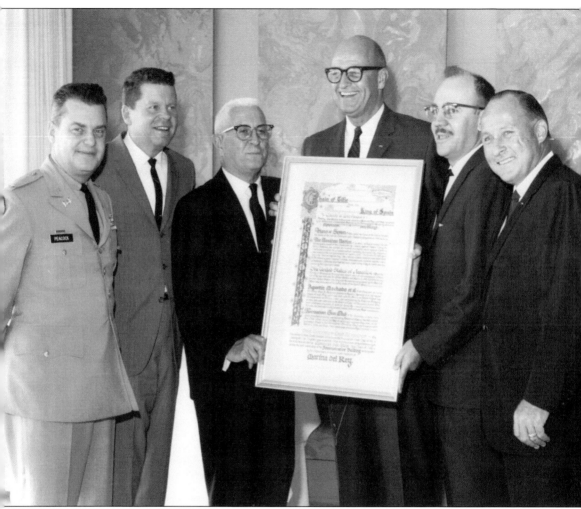

The Recreation Gun Club deeded the land upon which the Administrative Building was to be built to Marina del Rey in a chain of title deed. The deed progressed historically from the king of Spain, to Mexico, then to the United States, then to Agustin Machado, et al., to Anderson Rose of the Recreation Gun Club, and finally to the Administrative Building at Marina del Rey. Shown here are, from left to right, Col. Earl G. Peacock, US Army Corps of Engineers; Los Angeles County Supervisor 5th District, Warren M. Dorn; Supervisor 4th District, Burton W. Chace; Congressman James Roosevelt; Supervisor 1st District, Frank G. Bonelli; and Aubrey Austin Jr., chairman, Small Craft Advisory Commission. On December 8, 1958, Deed No. 4594 from the Recreation Gun Club to the County of Los Angeles was recorded. (Courtesy of LACDBH.)

Charismatic Burton W. Chace was elected Fourth District supervisor of the Los Angeles County Board of Supervisors in 1954. Chace presented the new concept of a public/private real estate development, in which the county would own the land and water, private developers would build out the land and then pay the county rent for the leasehold. Having been a businessman and mayor of Long Beach (1947–1953), Chace had experience with "having to face payroll in private business" and believed that private interests could operate the marina better than government and eliminate mosquito abatement costs. He drew powerful support from the other four supervisors. The vision of the marina took hold, and the fact that the US Army Corps of Engineers could create a permanent water infrastructure excited everyone's interest and imagination. Burton Chace, seen here in 1954, became known as the "Father of the Marina." Unfortunately, he was killed in a freeway accident in 1972. The tragedy led to the addition of median barriers on all Los Angeles freeways. (Courtesy of LACBS.)

Sidney Blinder, seen here in 1969, was the builder of the eight-foot sabot sailboat, which became the favorite for racers of all ages and abilities. Learning the rules of racing was primary, followed by fine-tuning the techniques of sailing. The Sidney Sabot had a centerboard, which allowed water to splash into the cockpit, hence it was not a dry boat. But it did perform. Winning sailors of later years were usually Sidney Sabot graduates. The annual 24-hour race brought out sailors of all ages in Basin G, between Windjammers' and South Coast Corinthian Yacht Clubs, where competition was fierce and wet. (Courtesy of Greg Wenger Photography.)

In the photograph to the right, Frank Sinatra appears in the 1966 motion picture *Assault on a Queen*. Scenes of the movie were filmed in Marina del Rey's main channel. The submarine on the water was real, but it was unlikely to submerge in only 20 feet of water. Fisherman's Village had yet to be built, so the vacant lot was ideal for shooting films. Among several other productions filmed here was the television series *The Flying Nun* (below), which aired beginning in 1967. Sally Field portrays a member of a convent in Puerto Rico, where abundant breezes allow her to become airborne. (Both, courtesy of LACDBH.)

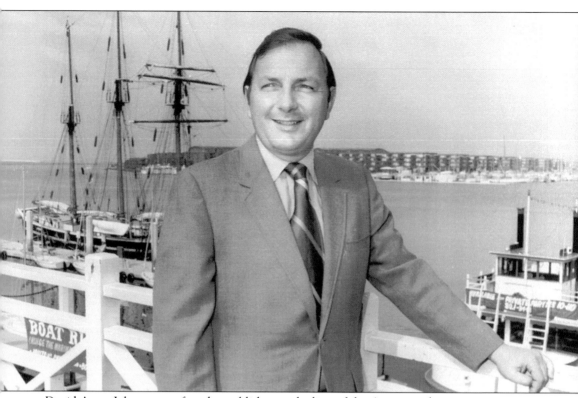

David Asper Johnson was founder, publisher, and editor of the *Argonaut*, the newspaper serving the marina beginning in November 1971. He wrote articles in high school, studied journalism at the University of Washington, and attended UCLA law school. Borrowing the image of *The Helmsman* statue for his masthead, $5,000 from his family, and the name *Argonaut* from a campus journal, Johnson chose Marina del Rey for his new publication. The paper grew from eight to sometimes eighty pages. By the 1980s, an advertiser testimonial exclaimed, "The *Argonaut* has made me rich, fat, and too proud to talk to my former friends." Decidedly a non-boater, Johnson navigated between roles as columnist, community leader, employer, editor, publisher, and, most important, devoted journalist. While he tried to keep content local, objective, and adjective-free, Johnson the columnist could paint the town in wonderful, witty colors. Referring to himself at times as "the publisher" and at other times as just "Dave," Johnson was a force to be reckoned with. (Courtesy of Greg Wenger Photography.)

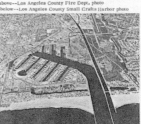

The *Argonaut* newspaper's first issue, November 25, 1971, had four advertisers and eight pages. With no office, the newspaper had a low overhead. Callers requesting to drop off a press release found publisher David Asper Johnson insisting on personally picking up their item instead. Plans to row slip-to-slip, tossing papers into the cockpits of every boat, were quickly tossed overboard by the harbormaster. Instead, the *Argonaut*'s first issues began to emerge from the trunk of a Karmann Ghia sports car, with residential distribution delegated to the US Postal Service. Delivery operations were again brought in-house when a New Year's Eve options story reached mailboxes a day after the ball dropped. Moving into its first office on Washington Street, between the canal and Baja Cantina, the newspaper soon relocated to the scenic seventh floor of the Washington Square Office Tower (330 Washington Street). Success, staff, and delivery vehicles grew. "We've now expanded to a fleet of 25 Karmann Ghias," new hires were told on their first day of work in the late 1990s. (Courtesy of the Argonaut, Inc.)

Soon after the *Argonaut* was founded in November 1971, Darien G. Murray (pictured) approached publisher David Asper Johnson to suggest the newspaper include boating news, and she immediately became the boating columnist. A year later, when Ed and Betty Borgeson, publishers of the Marina's first journal, *Del Rey Dinghy*, retired, *Dinghy* magazine was acquired by Johnson, with an arrangement to share ownership with photographer Greg Wenger and Murray. Murray soon became editor and publisher of the *Dinghy*, which served the local boating community for many decades with detailed prose. When Murray passed away on October 2, 2002, the Association of Santa Monica Bay Yacht Clubs (ASMBYC) held a standing-room-only memorial at the Burton Chace Park Community Building. Among the memorable eulogies was an opening line from a man who had flown from Australia to attend: "I'm Darien's son—but I'll try to be brief." (Courtesy of Greg Wenger Photography.)

Jacques-Yves Cousteau explored Earth and its water system. From 1943, when he and Emile Gagnan developed the first regulated compressed-air-breathing device for deep-sea diving, Captain Cousteau was a leading spokesman for the protection of the underwater world and the global environment. He visited Marina del Rey in the 1980s to see the marina and to promote water environmental protection. (Courtesy of Greg Wenger Photography.)

Lloyd Taber, original leaseholder of Parcels 38 and 39, had visions of two high-rise hotels, called the Commodore Club. In the final development decision, two restaurants emerged, along with the Civic National Bank office building on Admiralty Way. The Lloyd Taber Marina del Rey Library was named in his honor for his contribution to the library's nautical wing expansion in the 1990s, headed by the Marina Foundation. (Courtesy of Greg Wenger Photography.)

Howard R. Hughes Jr., test pilot, aerospace manufacturer, inventor, filmmaker, and real estate magnate, is shown in 1934 with his "Winged Bullet" propeller-driven aircraft in 1934. Hughes Airfield was on the site of Hughes Aircraft Company in Culver City. The site is present-day Playa Vista, a planned community. The old airplane hangars have been converted to sound stages and high-tech corridors. Land swaps, complex acquisitions, and mergers allowed Hughes to maintain a profile in Marina del Rey. The Marina City Club's west tower, the first of three towers constructed, is shown below in 1978 in dramatic nighttime reflection on the waters of Marina del Rey harbor. (Left, courtesy of Summa Corporation/MDRHS; below, courtesy of Greg Wenger Photography.)

The Hercules Flying Boat, known as the "Spruce Goose," is pictured above as it emerges from the Hughes Aircraft hangar to begin its trip by land to Long Beach, where it is to take its test flight. Originally, shipbuilder Henry Kaiser teamed with Howard Hughes to build the prototype, the largest aircraft ever built at that time—218 feet long and 79 feet high. As of 2014, the Spruce Goose still has the largest wingspan of any airplane ever constructed. Pictured below in transit on Jefferson Boulevard is the fuselage section. The Goose's first test flight was successful, but the program was canceled. After its only flight, the one and only prototype was retired. It is now a tourist attraction in Oregon. (Both, courtesy of Summa Corporation/MDRHS.)

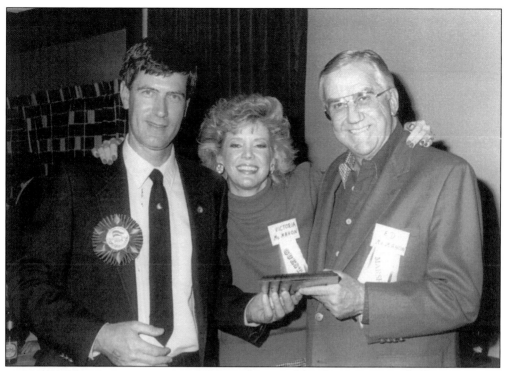

John Cruger-Hansen (left) was dockmaster of Marina City Club and the 1986 chairman of the Pioneer Skippers Christmas Boat Parade. The decorated boats were led by grand marshal Ed McMahon and his wife, Victoria (shown here). At one time a resident of Marina del Rey, McMahon, the popular television announcer on Johnny Carson's late-night show, was an all-time favorite of the parade participants. (Courtesy of Greg Wenger Photography.)

Mark Spitz, multiple gold-medal winner in Olympic swimming, was the 1984 grand marshal of the Pioneer Skippers Christmas Boat Parade. Spitz also sailed his own boat in regattas held in Marina del Rey. During the 1984 Olympics, Marina del Rey yacht clubs produced many of the triangular courses for the Olympic committee. (Courtesy of Greg Wenger Photography.)

Notable yachtswoman Peggy Slater owned a series of beautiful wooden boats, all named *Valentine*. All of the boats had a large red heart boldly applied to the foresail and a white spinnaker. An exemplary competitor, Slater, seen here in 1974, shared her innumerable talents with many women sailors in Marina del Rey, and she was a very successful yacht broker. (Courtesy of MDRHS.)

Sharon Sites Adams sailed her 25-foot Folkboat *Sea Sharp* solo from Marina del Rey to Hawaii on June 12, 1965. She is the first woman to sail alone across the Pacific Ocean, from Yokohoma, Japan, to San Diego, California, from May to July 1969. Adams, who has sailed around 71 South Pacific islands, shares her adventures with civic and children's groups in Oregon. (Courtesy of Jason Hailey Photography.)

Kareem Abdul-Jabbar, author, philanthropist, and the National Basketball Association's all-time leading scorer, enjoys spending time in Marina del Rey. The former Lakers star is seen here riding a bicycle on the picturesque waterway alongside the docked boats in 1979. (Courtesy of Greg Wenger Photography.)

Known to early locals as "Gypsy John," John "Jack" Edward Wright serenaded listeners at Mother's Beach and yacht clubs with his melodious squeeze-box (accordion). Gypsy John, a mathematics teacher and US Marine Corps veteran of World War II in the Pacific theater, lived aboard and captained boats, including the famous Kettenburg 50 sailboat *Rogue*, which won a 1960s yacht race from Los Angeles Harbor to Tahiti in record time. Wright is seen here in 1976. (Courtesy of Greg Wenger Photography.)

The Marina del Rey Chamber of Commerce gave plaques to 1982 Citizen of the Year nominees for outstanding service to the Marina del Rey community. Shown here are, from left to right, Willie Hjorth, Uta Ferguson, Victor Adorian, Ralph Zimmerman, Jerry Epstein, chamber manager Gerri Kazmeier, and Aubrey Austin Jr., chairman, Small Craft Harbor Commission. (Courtesy of Greg Wenger Photography.)

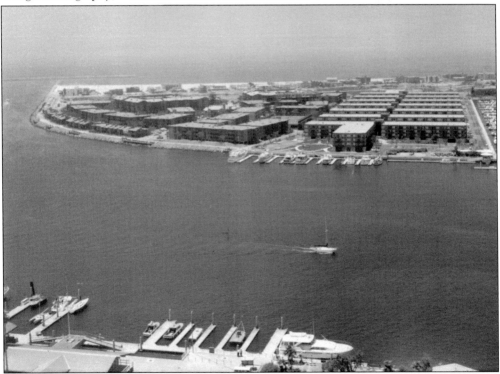

The south end of the marina peninsula is seen in this 1972 aerial photograph. The townhouses and apartments of Mariners Village on Via Marina have been constructed. There are no boat slips in the main channel entrance area. The Pacific Ocean is seen in the background, with the faint line of the breakwater above the white beachfront at left. This residential area is now planned for redevelopment. (Courtesy of LACDBH.)

Happiness is "messing about in boats," to take a phrase from Kenneth Grahame's *The Wind in the Willows*. Marina del Rey offers just that for any of Los Angeles' residents who love the water. Boats, dinghies, paddleboards, sailboards, runabouts, kayaks, canoes, outriggers, and "dock sailing" are the options. The marina would not exist without the dedication of the visionaries and the early developers who believed enough in the dream to finance an unknown project and hope it would not fail. Among those who made it happen are David Tallichet, Stan Berman, Bryant Morris, Jerry Epstein, the Ring brothers, Stanley Black, Jona Goldrich, Sol Kest, George Ponty, Max Fenmore, David Jennings, Abe Lurie, and the yacht clubs, in addition to government agencies. As the man-made Marina del Rey Small Craft Harbor enters a new round of redevelopment, users will enjoy updated facilities in one of Southern California's most beautiful resort-like communities. (Courtesy of Greg Wenger Photography.)

About the Organization

Not often does one get the chance to be in on the ground floor of a new city, a new harbor, and a new life's change. That is the case with Greg Wenger, photographer from New York, and Willie Angel Hjorth, a transplant from San Francisco. Wenger said, "Snow no more," and Willie's husband, John, said, "Let's go sailing!"

Weather and job opportunity brought the two founders of the Marina del Rey Historical Society (MDRHS) together, and they have been involved in Marina del Rey for a combined total of about 94 years. Greg Wenger was the leading photographer, with an amazing artist's eye during these years. Most businesses contracted his services. Willie and John began a marine business in 1964, and it grew with the marina.

The Marina del Rey Historical Society achieved nonprofit 501c3 status on September 10, 2007. Acquisitions, catalog systems, and storage became challenges, as did finding financing methods in order to preserve photographs, documents, and related data into a retrievable resource and archive for future research and education. A website is under construction, and the use of multimedia displays units is being readied.

We thank Arcadia Publishing for the opportunity to pictorially present our history and for its help in putting together the broad brushstrokes of Marina del Rey development. For MDRHS, the work has opened the door to present more detailed chapters of the history uncovered in this man-made harbor and city.

The existence of Marina del Rey is unique and a paradigm for the future, and it should be recorded as a guideline for future developments.

On April 10, 2014, one year prior to Marina del Rey's 50th-birthday celebration, the Marina del Rey Historical Society opened its waterfront gallery at Fisherman's Village.

Thank you, Arcadia and staff, for the chance to tell a little bit of our story.

Marina del Rey Historical Society
13737 Fiji Way, Ste. C-3
Marina del Rey, CA 90292
Willie Angel Hjorth, President

Discover Thousands of Local History Books
Featuring Millions of Vintage Images

Arcadia Publishing, the leading local history publisher in the United States, is committed to making history accessible and meaningful through publishing books that celebrate and preserve the heritage of America's people and places.

Find more books like this at
www.arcadiapublishing.com

Search for your hometown history, your old stomping grounds, and even your favorite sports team.

Consistent with our mission to preserve history on a local level, this book was printed in South Carolina on American-made paper and manufactured entirely in the United States. Products carrying the accredited Forest Stewardship Council (FSC) label are printed on 100 percent FSC-certified paper.